READING FOR A LIVING

HOW TO BE A
PROFESSIONAL STORY ANALYST
FOR FILM AND TELEVISION

by T. L. KATAHN

BLUE ARROW BOOKS
LOS ANGELES, CALIFORNIA

READING FOR A LIVING
How to be a Professional Story Analyst
for Film and Television
by T. L. Katahn

Published by Blue Arrow Books
P. O. Box 1669
Pacific Palisades, CA 90272

Copyright © 1990 by T. L. Katahn
All rights reserved. No part of this book may be used or reproduced in any manner
whatsoever without written permission from the publisher.

Library of Congress Catalog Card Number: 90-81591

Publisher's Cataloging in Publication Data
Katahn, T. L.
Reading for a Living: How to be a Professional Story Analyst for
Film and Television - First Edition
Includes index.
1. Story Editors (Motion pictures)--Handbooks, manuals, etc.
 I. Title
2. Motion picture plays--History and criticism

ISBN 0-9625803-9-2

Cover design by Raess Design, Los Angeles

Printed and bound in the United States of America
Recycled text paper

10 9 8 7 6

TABLE OF CONTENTS

PREFACE

As everyone knows, Hollywood changes rapidly from day to day, from who's running the show at film companies to the area codes for their phone numbers. Since *READING FOR A LIVING* was first published six years ago, Triad Artists, Inc., where I worked as a story analyst, has disappeared, the friend who once got me the reading job is now an agent in his own right, and instead of screenplays, I've been writing a novel, soon to be published.

After six years in print, however, I thought *READING FOR A LIVING* might be due for an update, maybe even a revised second edition. So I started researching the idea.

The feedback I received indicates that some companies pay slightly more for coverages than they used to, yet the number of companies that pay very little or nothing at all, using unpaid interns to read for them, may have increased. Still, story analysis, even as an intern, is one of the best ways to get into the business, and it's a required skill for jobs in development.

As for other changes, it appears more readers use FAX machines, computer modems or disks to turn in their work than they used to.

How to be a good story analyst, however, has not changed. And *READING FOR A LIVING* still tells you how. My contacts repeatedly told me that the fundamental information provided in the first edition of this book remains accurate and pertinent.

I concluded that a revised edition at this stage would be redundant.

So here it is, the original edition, back by popular demand. I'm pleased to be able to say that as of this writing, over fourteen thousand copies of this book have been sold internationally, and I am confident that it will continue to offer the kind of training that will benefit story analysts and their employers, as well as writers, directors, development executives — in fact, practically everyone who works in the entertainment industry.

I remain grateful to those who originally provided information, interviews and other assorted "ins," notably Gregory Avellone, Fred Calvert, Richard Curtis, Rosanne Ehrlich, Tim Evans, Sharyl Fickas, Steve Gerard, Mark S. Goldstein, Paul Gurian, Walter Hanley, Dona Tapp Haywood, Rick Jaffa, Andrea Jaffe,

Ellie Kahn-Evans, Sherry Lansing, Jon Long, Susan Lynch, Susan Marks, Criss Martin, Rachel Parker, Richard Pine, Andy Robinson, Amanda Silver, Don Spradlin and John Truby.

Much appreciation goes to those who responded to my latest research, including Andrew Fumento, Gibran Perrone, Karen Peterkin, Alison Riback and Damon Ross.

Many thanks also to those helpful people, past and present, who prefer to remain anonymous: you know who you are.

I also want to thank Gwen Feldman, Jim Fox, Tim Merell and all the staff at Samuel French Trade and Samuel French Bookshop for helping to make this book a success.

And special thanks to all the readers.

T. L. Katahn
Los Angeles, 1997

CHAPTER ONE
BORN TO READ

When I was growing up, I hid books in my room so I could read at night when my parents thought I was asleep. I kept up a pretense of Fear Of The Dark long after the monsters had disappeared from under my bed and relocated to another child's nightmares. I read entranced for hours in the glow of my "nightlight": the swath of half-light streaming in from the open door to the next room.

And then there were the movies. My idea of heaven was Saturday night, a bowl of popcorn, Hitchcock, and me.

If you love reading and movies as much as I do, then reading *for* the movies - story analysis - is a job tailor-made for you.

Yet reading professionally is not all fun and games. It's more like boot camp for the brain. As a story analyst, you'll read every imaginable type of story and style of writing. Naturally, some of it you'll love, some of it you'll hate,

and most of it will fall somewhere between the two extremes.

You'll work under a deadline. You'll learn to express your thoughts quickly and concisely.

You'll get an advance look at many of the newest projects in development at major studios and agencies. You'll learn what's hot, what's not, and why.

You'll learn what it takes to make a good blueprint for a movie; in other words, a strong, workable script. You'll learn more about your own personal tastes, too.

There is always a high demand for good, responsible story analysts, and there is always more work, especially in centers of the entertainment industry such as Los Angeles and New York. Television and motion picture studios, talent and literary agencies, directors, producers, actors and actresses daily receive a deluge of scripts and books. Executives don't have time to read and analyze everything themselves, and that's where you come in. The jobs are there and well-trained applicants will be the ones to get them and keep them.

And yet, through a tremendous oversight on the part of our educational system, you can't get a Doctor of Reading and Comprehension degree from a university. There is at present no standard of formal education for story analysts, or for that matter, for agents or other film industry executives. There are very few classes in story analysis or even reading comprehension. To my knowledge, there has been no textbook or manual to serve as a guideline in this specialized field until now, with the publication of this book.

Until now, if you got hired as a story analyst, you probably got your training haphazardly, on the job. But your boss didn't have time to offer you more than occasional tips on what your job entailed. Unless you had a natural knack for it, you could easily lose your job before you had a chance to learn what was expected of you.

The primary goal of this book, then, is to provide you with the skills you need to get a job as a story analyst and to do that job well.

A secondary goal of this book is to help create a standard in the industry for the training of story analysts. In this way, all of us, from aspiring new writers to major studio executives, can submit projects for consideration in full confidence that professional readers are analyzing the work as effectively and objectively as possible.

LEARNING YOUR CRAFT

Of course, you already know how to read, or you wouldn't have made it even this far into this book. But there are certain elements story analysts must watch for as they read, as you'll discover in Chapter Three.

In addition to reading itself, story analysts write about what they've read. This is called *coverage* or *analysis*.

The major components of coverage are a *synopsis*, which describes the main action of the story, and your *comments*, what you really thought about the script or book. Sometimes you'll be asked to include a *character breakdown*, which lists the main characters. These major coverage components plus some minor ones are all described in detail in chapters to come.

But first, read Chapter Two to learn about the tools you need to get started.

Next, Chapters Three through Eight take you step by step through the analysis process, from the first glance at a script or book through the writing and final editing of your coverage.

OPPORTUNITIES FOR ADVANCEMENT

Reading for a living is a coveted job, but it is also an entry level job. Luckily, while readers perch on a bottom rung of the success ladder, everyone in the industry knows good readers have to be intelligent and articulate. They are respected for their abilities and promotions do happen.

Reading for a living is also good training for writers. Many working writers in Hollywood have gained experience and insight into the film industry by working as story analysts.

Chapters Nine through Eleven give you the bottom line:

- how to apply successfully for that first reading job
- once you get the job, how to keep it as long as you want it
- how much money you can expect to make as a reader
- how much clout you will really have in saying "yea" or "nay" to a project
- what your coverages will be used for and by whom
- how you can advance your career through reading

Chapter Twelve gives the freelancer a brief look at how to keep track of income and expenses for tax purposes. As a freelancer, you can take deductions that can save you money in taxes.

Chapter Thirteen includes sample coverages so you can get a feel for different formats and writing styles.

In the Appendices, you will find a summary outline for quick reference when writing coverages, format guidelines for books and scripts, a glossary of screenplay terms, and a list of commonly used proofreader's marks for editing purposes.

A LITTLE "BACK STORY"

I wasn't looking for my reading job. I was supporting myself with royalties from previous writing projects while I made my first attempts at screenplay writing. My friend Don Spradlin was working at Triad Artists, Inc. when he happened to overhear story editor Criss Martin saying she needed a few more good readers. For some reason which still escapes me but for which I am grateful, Don mentioned me to Criss, extolling my virtues as something of a Boy Scout among authors: responsible, trustworthy, hardworking, and so on. Criss told Don I could give her a call.

I thought reading a hundred scripts or so would be good training for me as a scriptwriter, and why not get paid for doing it? I called Criss, confessed I'd never worked professionally as a reader before, and agreed to do a free sample coverage. She loaned me a few other readers' coverages for reference, and a trial script, which was already in development although I didn't realize it at the time.

I hurried home, whipped out my trusty word processor, and got to work.

Which script was it? **Navy Seal**, due out as of this writing in the summer of 1990, starring Charlie Sheen. You'll find my sample coverage of this script in Chapter Thirteen.

To my joy, Criss liked my coverage. To my sorrow, she didn't have work for me right away. She said she'd keep my name on file as an alternate reader, though.

Well, we all know where "on file" usually leads: nowhere. I drove home thinking I'd never get any work from Triad.

A few days later, I dropped by the agency to thank Don anyway. I ran into Criss in the elevator.

"Do you want to work?" she asked.

"Sure," I said, trying to act nonchalant.

"Come by my office."

Behold, a reader is born. This was a case of being in the right place at the right time, proving that truth can be more clichéed than fiction. Criss happened to have extra work that day; I happened to appear.

A stroke of good fortune like this could happen to you. Many readers get their jobs the way I did, by word of mouth.

However, rest assured that there are plenty of people who got their reading jobs without benefit of networking. Though reading this book doesn't *guarantee* you'll get a story analysis job, you *will* learn how to create opportunities for yourself, and you will know how to do the job well once you get it.

WHO IS IN THE AUDIENCE?

The audience for this book is fourfold.

First, anyone who lives in a center for film and television production can earn extra income through story analysis. Creative artists of all types, homemakers, and others find story analysis attractive because they can work part-time or full-time while retaining the freedom to pursue their other interests. Story analysis can also be a foot in the door to the entertainment industry. Many people find professional reading more appealing than starting as a secretary or in the mail room.

Second, development executives, story editors, and those who are already working as story analysts will find this book provides excellent review or further training.

Third, writers will discover this book is a concise guide to the fundamentals of good writing. But perhaps more important, writers must write for readers. When a writer submits a manuscript, it almost invariably goes to a story analyst, even when an executive also chooses to read it. *READING FOR A LIVING* offers an edge to writers with its candid look at what story analysts and executives want in a project, from packaging to content.

Fourth, anyone who simply wants to learn more about how to appreciate a film or book will benefit from reading *READING FOR A LIVING*.

IN SUM

This business is always in flux. A class or a book, even this one, can't give you the very latest information. You can't buy the kind of valuable experience you need to

succeed. Instead, you have to get it on your own time, through your own effort.

Yet in one of life's little miracles, you can be paid while you're gaining that experience, by working as a story analyst.

CHAPTER TWO
TOOLS OF THE TRADE

If you land a staff position as a reader, your employer will provide office space, equipment, and materials. If you're freelance, you'll work at home and provide your own tools of the trade.

Being freelance has its advantages and disadvantages. A disadvantage is that you spend time travelling to and from the company to drop off and pick up work without receiving in return benefits such as insurance or other perks that a full-time employee would get. Advantages include the freedom to work more or less at your own pace, in your own space. Bearing your deadline in mind, you can schedule your work hours at your convenience.

You also have more control over how much you want to work, part-time or full-time. Some readers cover four scripts a day, others may choose to do four a week, while

others may do one every few weeks or so as a "reserve reader" when a company is in a bind.

Furthermore, though some say it's tougher in New York City, in Los Angeles you can take a vacation for a week or so and still find work when you get back. (We're very mellow here in L.A.) In fact, if you have been consistent and responsible, your employer may let you take several months off, to work on another project, for example, then rehire you when you're ready.

> A major advantage for the freelancer is that expenses for equipment, supplies, industry publications, even movie tickets are often tax deductible. See Chapter Twelve for more information.

EQUIPMENT

An essential item is a typewriter or, better yet, a word processor with a decent printer (heavy dot matrix, letter quality, or laser.) No professional reader turns in handwritten coverages. Occasionally you may find yourself in a situation where your employer only wants a verbal report on what you have read, but the majority of coverages are typewritten.

Word processors are to writers what power tools are to carpenters. Speed is enhanced immensely. Clean copy is much easier to generate. Using a word processor, you can store files on disk containing formatting data: no more measuring of margins! You can store standard coverage forms like the grid. You can even store your invoice form.

You can copy these files again and again and fill them in for each coverage, saving you time and reducing the chances of typographical errors. The printer feeds paper for you: no more inserting each individual sheet of paper by hand. Editing becomes a breeze: no more retyping of entire pages every time you revise or make a mistake, no more messy, time-consuming correction fluids.

If you're in the market for a word processor, ask for recommendations from people who are happy with theirs. Writers who use word processors are a lot like grandparents who love talking about their grandchildren. Get them started and they'll cheerfully bore you to tears with specifications and techno-jargon. Take notes!

Go into computer stores and test various hardware and software programs. Find a keyboard that has a good feel, software you like, and a store that provides customer support after you've bought your system.

I'm writing this book on an IBM-compatible Tandy 4000 SX. In my experience, Tandy hardware has always proved to be reliable and lower in cost than comparable machines made by other companies. I use the *FRAMEWORK* word processing software by Ashton-Tate. While this is not the most well-known, it's the easiest program I've found so far to learn and to use. Many writers swear by Microsoft *WORD*, however.

REFERENCES

Other essential items if you want to write *well* include:

- a dictionary
- a thesaurus

- A copy of *THE ELEMENTS OF STYLE*
by William Strunk, Jr., and E. B. White

You can often buy these reference books second-hand if you want to save money.

Another handy reference is an up-to-date guide to movies and videos such as Leonard Maltin's *TV MOVIES & VIDEO GUIDE*. When you're reading a script that reminds you of one that's already been produced, a movie guide can jog your memory about the details. Maltin's book, a mass-market paperback, lists thousands of films and includes information about when they were made, directors, cast, and brief summaries of the plots. There are other more expensive and grandiose guides, but one like this will probably suffice for your needs.

Directories of local production companies, agencies, directors, and writers are also valuable though not crucial. See Chapter Nine for details on directories.

OFFICE SUPPLIES

You will need blank 8½ by 11-inch typing paper or printer paper, typewriter or printer ribbons, pens and pencils, paper clips, a stapler, correction fluid or the like if you're using a typewriter, and other miscellaneous office supplies.

EDUCATION

Readers range in educational background from those who never finished high school to those who have a Ph.D. from an Ivy League college. Whatever your background, you must take it upon yourself to prepare for your reading job and stay informed.

See as many movies as you can. Go to the theatre. Rent videos if you have a VCR. The more you see, the more you'll understand the different genres and the more you'll get a feel for how a script comes alive on the screen. See all kinds of films: dramas, comedies, horror films, action movies, everything. Be sure to include foreign films, even though you may rarely read foreign scripts. See the hottest, the latest, the independents, the classics.

Read scripts and books on your own. If you live in Los Angeles, you will find a number of libraries have copies of original film scripts (see Chapter Nine for details). You can also find more and more scripts being published in book form. However, be aware as you read them that these are usually not in correct screenplay format.

Read some screenplays that you can also watch in film form elsewhere.

As for books, visit your local libraries and bookstores. Stay aware of the trends. Watch the bestseller lists. Read the great classics and the popular newcomers, as well as lesser-known works.

In addition to screenplays and books, readers are sometimes asked to cover other material.

Plays are written for the stage and often are too static to translate well to film. Though sets can be changed for each act in a stage play, there simply isn't the same wide range of movement in a play as there can be a film. Plays also tend to be talky: much of the action and meaning is expressed in the dialogue. You don't see what happens, you hear about what did happen or what will happen, or how a character thinks or feels, which is not as effective on screen as on the stage in the presence of live actors and

actresses. Naturally, there are exceptions; a number of plays have been made successfully into films. **Driving Miss Daisy** is a recent award-winning example. And of course, there's Shakespeare.

Teleplays (scripts for television) are generally written in acts much like a stage play. They range in length from three to seven acts.

Treatments are ideas for screenplays written somewhat like short stories, in the present tense. They are a more comprehensive form of synopsis (see Chapter Four) and may be anywhere from several to sixty pages long.

Outlines are treatments broken down into scenes.

Though treatments and outlines are not standard library or bookstore fare, you can find plays and in some cases, teleplays there. Familiarize yourself with these forms.

Leaf through copies of the trade dailies, such as *VARIETY* or *HOLLYWOOD REPORTER*, and the entertainment sections of your newspaper in order to see what's happening in the business. Read the reviews. See the movies reviewed and form your own opinions.

Take a class or two. Though you may have an innate sense of what works and what doesn't, a good class can give you tools and terminology to help you pinpoint the problems in a story and put those concepts into words. Even if you have experience as a reader or writer, a good class can serve as a refresher course.

In Los Angeles, the American Film Institute offers an in-depth story analysis class and other industry-related classes. Call 213/856-7600 for more information.

Some continuing education schools also offer night classes in how to be a story analyst. These classes are generally less than comprehensive but are a good way to get an initial overview of the field.

Another L.A. option is to take one of the many screenwriting classes available, such as John Truby's Story Structure Class, which is excellent for both beginners and professionals who want to hone their skills and get a jolt of inspiration. Call 213/454-7499 for more information. For those who don't live in L.A., Truby's class is also available on cassette.

You can look for classes in university settings too.

> Phone numbers in this chapter are provided for your convenience and are current as of this writing.

Study at home. If you want to brush up on your writing skills in the comfort of your own home, there is a plethora of books on how to write. A few are worth reading. One of the best is Lajos Egri's *THE ART OF DRAMATIC WRITING.* Though he wrote it in 1946 and concerned himself with stage plays, much of what Egri said holds true today for plays as well as novels, films, in fact, any fictional or biographical work. His ideas on character development are exceptional. *MAKING A GOOD SCRIPT GREAT* by Linda Seger is another good book on how to write. Browse through your local bookstore for other writing manuals that appeal to you. You may want to take a look at *WRITER'S DIGEST,* a magazine that offers helpful articles for writers.

You can even buy computer software that functions as training for writers, such as *WRITEPRO* by Sol Stein.

Arm yourself with knowledge. The better your education and the other tools of your trade, the better your coverages will be.

CHAPTER THREE
THE ART OF READING
WHAT TO LOOK FOR, WHAT TO IGNORE

You ease back into your favorite chair, put your feet up, take a sip of tea, and open the cover of a new script. You feel a sense of adventure mixed with relaxation. Your cat snuggles purring in your lap. A breeze scented with jasmine and/or smog wafts gently in through the windows. You begin reading. After a few pages, the story catches you and you read with growing interest. A sudden revelation hits you and you gaze out the window musing on its profundity.

If this is how you envision your life as a reader, you are in for a few surprises. Yes, reading is fun, and sometimes even inspiring, but as often as not you'll be reading something that unquestionably demands payment or you'd never read past the first ten pages. Plus, you've got a deadline. You don't have time to gaze out the window.

Reading professionally requires vigilance. Here are a few things to look for and a few shortcuts for getting the job done more efficiently and more effectively.

> Keep a notebook and pen or pencil handy while you read so you can jot down ideas and reactions as they occur to you. (It's bad manners for story analysts to write directly on scripts or books. Ask Amy Vanderbilt.) When you get around to writing the comment section in your coverage, you will have plenty of notes to refer to. The actual writing will be more a matter of simply organizing your thoughts.

WHAT TO LOOK FOR

Plot. Obviously, you must pay attention to what happens in the story as you read. Focus on what the story is really about (the concept) as well as what the main action is.

Characters. Obviously, you must also pay attention to your main characters. You will be mentioning them in all components of your coverage.

In most screenplays written by competent writers, any speaking characters' names are written in ALL CAPS the first time they appear in the stage directions. Main characters will be described briefly at this juncture as well. You will soon learn to be thankful for educated screenwriters who do this. It makes your job much easier, makes casting easier, and gives a clearer sense of the whole story.

When a writer bothers to give a character's age, general appearance, and a hint or two about personality, this is often a clue that you've got a main or supporting character here. Make a mental note or jot the page number down in your notes; you will refer back to it, especially if you will be writing a character breakdown.

> Before you begin reading a project, leaf very quickly through it to see which character names appear frequently throughout. Bingo! You know who the main characters are and you know to watch the action around them more carefully than the minor characters. This saves reading time. A quick leaf-through also gives you a feel for how "talky" versus action-oriented the story is.

Purpose. Consider the purpose of your coverage as you read.

In general, your mission is to report the strong and weak points of the story as clearly and objectively as possible. To do this well, you will need to focus on the important elements and anything that is unique about the project. Disregard inconsequential details. (In Chapter Six, you will find in-depth discussions of the important elements.)

In specific, the purposes of coverages may vary.

For instance:

- A script may have been sent to a talent agency for casting. If so, pay special attention to the characters: appearance, age, behavior, background.
- A script may have been submitted to an agency for packaging. Perhaps a production company is looking for a director and a couple of stars for the leading roles. In this case, pay attention to the main characters and the tone and style of the piece. Different directors and talent are appropriate for different types of films.
- If the project is directed toward a particular actor or actress, you may be asked to give your opinion about whether you could see that person playing that role. However, if the role is inappropriate for one actor, it might be good for another. Therefore, some companies prefer you to write your opinion about the role on a separate page from the rest of your comments. Other companies prefer that you address comments to the role in question without mentioning any actors' names. Ask your employer about the company's preferences when you accept the script for coverage.
- If an agency requires you to cover one of its own clients' scripts, your coverage may be used by an agent to help sell the work. In this case, your boss will want you to play up the positive aspects and play down the negative ones in your comments. You don't have to gush your

approval of the work; be honest, but be as dip-lomatic and optimistic as possible.

- Many scripts are submitted as writers' samples by writers looking for representation or a pro-duction deal. In such cases, pay special atten-tion to the writing itself. Is it clumsy? Is it classy? Does the writer have a grasp of the craft of writing? (Refer to Chapter Six for more on how to evaluate writing.) There is a tendency in the industry to be more critical of new writers' samples than other submissions. If you recommend new writers to busy execu-tives who must then read the submissions them-selves, those writers had better be good.

- Books are often covered to see whether they are adaptable to film. Pay special attention to the "visual value" of the work, as discussed later in this chapter.

- If you read for a production company, you may be asked to be particularly conscious of budget considerations.

- If you work for talent, you will be one of the privileged few who knows what kind of prop-erty they want to appear in next. Maybe he wants to do an action-adventure and play a hero now that he's established himself as a ro-mantic lead. Maybe she's a comic who wants a role with some meat on it so people will take her acting more seriously. Keep these things in mind while reading.

As you learn your bosses' likes and dislikes, you'll be able to screen out scripts that don't come close to what they want. Yet reading requires keeping your eyes open to possibilities. As Gregory Avellone of Tig Productions says, "You don't have to have the perfect script. You have to just be passionate about what you do have and then try to build it into a good script." If you come across something in your reading that has strong potential, be sure to point it out to your boss.

"Visual value." A motion picture is a picture that moves. This tautology has implications many of us tend to forget. Whatever you read, whether it's a script, a play, a book, or a treatment being considered for the screen, pay attention to how visual the story is.

Ask yourself if it brings to mind clear image after image, what I call "visual value." Ask yourself how much action there is. (Perhaps we could call this the "motion quotient.") Is character development internal and therefore unseen, or are the characters exposed through their behavior and dialogue?

Since the medium of books allows for heavy doses of internal action and character background, novelists can often get away with that kind of writing. In fact, it can be wonderful. Unfortunately, sometimes screenwriters, who can't get away with it, tell us rather than show us their characters' thoughts and feelings. Will a theatre audience know what's going on, or is the writer having a private party in the stage directions? If the latter, that doesn't mean the story won't work on film; it may simply need to be rewritten.

Test your own visual sense. Pick a book that has been made into a movie. There are plenty of them, from **Gone With The Wind** to **Dune**. Read a book, read the screen adaptation, then see the film. How well did the book translate to the screen? If it didn't translate well, is that because of innate lack of visuals in the book, or because of poor choices on the part of the movie-makers?

WHAT TO IGNORE

The little things. No matter how much it may irk you, disregard typos, misspellings, occasional grammatical slips, and lack of knowledge of correct format unless these make the work unintelligible or the story is terribly bad in other more important ways. In the latter cases, you may want to mention the technical errors in your comments to add weight to your opinion that the whole work is amateurish.

Skimming. Not a skateboarding term. To skim, as you probably know, is to skip parts of, to thumb through, to glance lightly over without dwelling upon. (By the way, it's bad form to end sentences with a preposition. Read *THE ELEMENTS OF STYLE.*)

To skim does not mean to skip, however! Though you can usually get a feel for the merits of the story within the first ten to twenty pages, readers really do have to read the whole thing. Still, some parts are less crucial than others.

Skimming in a script. Unless you love chase scenes, you don't have to read them word for word. You won't have to report how many cars went down how many streets, and which ones turned end over end and exploded in flames.

First, you won't have room in your synopsis and second, who cares anyway? It will be much more fun on film than on paper, we hope. Once in a very great while you will come across a chase scene bursting with originality and taut excitement. Whatever the merits, in your synopsis you will still merely mention the chase scene and how it ends. Call it "wild" or "chaotic" if you like. Call it "thrilling." Call it "death-defying." Get a thesaurus.

The same "skim" rule goes for fight scenes and love scenes. Long detailed bloodbaths in horror scripts are eminently skimmable as well.

Skimming in a book. As mentioned before, books tend to be longer on character background and internal processes (thoughts and feelings) than scripts. These details can be fascinating, but unless they relate directly to the action, they may not translate to film. If you love this particular book and want to read it word for word for pleasure, fine. Otherwise, skim these sections. Get the essentials and move on. You'll save a lot of time.

Also skim chase, fight, love, and bloodbath scenes, as in scripts.

THE TELL-TALE SCRIPT

Aside from plain old garden variety bad writing, what are the warning signs that expose beginning writers and help you separate the pros from the novices? There are tell-tale signs that usually clue you in at a glance that you are reading a beginner's script. These are minor details that a completely unbiased and objective story analyst would ignore, but there is no such animal as a completely unbi-

ased and objective story analyst, so budding writers, take note and be sure your script does not have:

- more than a hundred and twenty-five pages
- spiral binding
- fancy binding
- three "brads" or fasteners in a binder instead of two. It is indeed annoying reading scripts with only two brads because the pages don't turn as well and the covers sag, but most people in the industry use only two.
- illustrations or photographs
- clippings from magazines or newspapers in a desperate effort to prove how timely a subject is. If it's really that timely, industry people will know it as well as the writer does.
- a list of characters as in a stage play
- a synopsis. The story analyst will write one anyway.
- a sales pitch on the first page, as in, "This is a wildly funny comedy." What's wildly funny is a matter of opinion.
- many copyright notices plastered on every page. One notice is enough.
- written subtext. "Once it's written, it becomes text," as story editor Tim Evans of Hometown Films so astutely points out.
- overabundant camera shots
- overabundant personal direction, telling actors how to act
- "CUT TO" written between every scene

As for books, it's amazing how many unpublished seven-hundred-page first novels lumber through the maze of Hollywood offices. You will find that the majority of these are overwritten. Very few subjects benefit from so much elucidation; very few beginning authors can pull it off. The standard length in the trade is around three hundred and fifty pages, give or take fifty or so.

Yes, there are a number of exceptionally good, exceptionally long novels with the kind of depth and complexity in characters and plot that deserve lengthy treatment. Such works are rarely the authors' first, but there are exceptions to that rule too.

And yes, sometimes an experienced writer will throw caution to the winds and add a third fastener or a fancy cover to a script, but usually such a *faux pas* is a warning that you've got a novice on your hands.

THE CLASS ACT

After perusing the list of horrors above, you might be wondering what the tell-tale signs of the professional script are. In short, it looks like hundreds of other scripts on the outside, but has something original or at least well-crafted on the inside. Aside from good writing, this script also has:

- standard script covers front and back. These are heavy-duty paper covers, fastened with two brads or fasteners, with the white "spine" of the manuscript paper showing.
- typed pages, not hand-written
- pages numbered consecutively
- correct format (see Appendix B for more on formats).

- visual stage directions
- concise stage directions. This is not a novel.
- correct use of screenplay terms

> Minor timesaver: when you're done reading, before you close the book or script, make a note of how long the work is so you don't have to look it up again later. You'll need the number of pages for your cover sheet.

READING AS A SPORT

Set aside a block of time for reading and writing your coverage when you won't be interrupted by ringing phones and doorbells or the demands of family, friends, or other projects. It is more difficult and takes longer to get through a coverage when you're constantly losing your place and your concentration, and you have to "rev up your engines" to get back into it again.

On the other hand, taking a short break now and then (without distractions) can be beneficial. Foolish as it may sound, there are physical demands to reading. Sitting in one place for long periods of time working your brain and not your body results in back and neck aches, tired eyes, and a sore behind.

Stretch for a minute. Get up and move around, make a cup of coffee, check the mail, or do some other brief task every half hour or so to alleviate the eye strain and other aches and pains. The break will refresh you mentally as well.

CHAPTER FOUR
THE PLOT CONDENSES
WRITING THE SYNOPSIS

In the world of professional reading, a synopsis is a condensed version of the plot.

Include in your synopsis the main action, any major character changes that apply directly to that action, and not much else. Leave out minor characters and subplots unless the main story line can't proceed without them. There is no need to include every "beat" in the script, i.e., every single event. Primarily follow the most important movements of your main characters. You will describe something of the characters' inner workings later, in the character breakdown and comments. Save your critique for the comment section as well.

Ask yourself, "What is the hero's goal or desire? What did the hero do or discover in each scene that is relevant to the goal? Why did the writer include the scene? What is

the point or focus? What are the important events that occur?"

The answers to these questions will help you boil the plot down to the basics. If there are no focal points or important events in a given scene, it shouldn't be in the story and it won't be in your synopsis. If there are an abundance of scenes that seem to serve no purpose and do not move the story forward, you will say so in your comments.

Remember, if you read something in a book that can't be translated to dialogue or some kind of action in a screenplay, you will usually leave such exposition out of the synopsis. Go where the action is!

STYLE

Unfortunately, it's easiest to write a deadly dull synopsis. You don't have much room to move, to be clever or descriptive. Yet as you streamline, your final product grows drier and more boring until it falls like a veritable leaf in autumn from the Tree of Compelling Interest.

There are several ways to liven up a synopsis and make it more useful at the same time.

First, write as much as you can from memory rather than going through the work page by page. This approach will help you tell the story in a natural, flowing way, and help you eliminate the less-than-crucial scenes that don't contribute directly to the story line. In fact, you may choose to begin your synopsis with a scene other than the one that opens the script or book. The same holds true for the ending.

Be sure to check the manuscript, though, to verify names, places, times, and other details.

Second, allow some of the mood or tone of the work to be reflected in your synopsis. This was a common complaint among many of the executives interviewed for this book: readers often don't know how to convey the essential tone of a piece. After reading some coverages, executives still can't tell if the work was a comedy or a drama. If you are writing about an action-adventure, make your synopsis fast-paced and exciting by using short sentences and action verbs. For a comedy, include the humor that's in the story. With love stories, you can afford to be more lyrical, and so on through the genres.

Third - and this will help you with the tone - choose evocative words. Judicious use of a thesaurus can help you add zip, variety, and individuality to your writing. "Running" can also be racing, hurrying, scurrying, dashing, or speeding, for example.

Fourth, as the traditional song says, "'Tis a gift to be simple." Avoid utilization of convoluted sentence structure or polysyllabic verbiage in a valiant effort to add complexity to the plot, sound like an authority, and show off your skills as the world's greatest writer. You'll probably end up sounding pompous or absurd instead, much like the preceding sentence.

Last, even if you don't like the piece, recount the story accurately. This was another complaint from execs: readers are often swayed by their personal dislike of a work and are unable to distance themselves from it enough to write a clear synopsis. As story editor Tim Evans advises, "Show the script in its best light. Even if it's a lousy

script, the whole point is to say, 'What are the possibilities here?'" Delivering a bland or plodding synopsis shows you in a worse light than the work you covered. Besides, you will give your evaluation in your comments; you can point out the blandness of the work in question then, if necessary.

In sum, the best synopses:
- tell the story concisely
- capture the mood or tone of the piece
- express any unique aspects of the piece
- point up the possibilities of the concept

You will discover that writing a synopsis is straightforward and easy so long as you don't get bogged down in the minor details of the story.

FORMAT

The length requested for the synopsis varies from company to company and even from purpose to purpose. Synopses range anywhere from half a page to two and a half pages for a script, sometimes more for a book. The longer the synopsis, the more beats you can include.

Format makes a difference in how many words end up on the page and how readable the final copy is. Each company has its preferences. Your employer will tell you which format you should use and how long the synopsis should be. For example:

```
A screenplay synopsis can be designed like a
business letter, as shown in this and the
following paragraph.  In such cases, you will
write single-spaced, left justified (in other
```

```
words, with no paragraph indentations), with
a space between paragraphs.

Sometimes you will be asked to turn in your
script synopsis in regular single-spaced
paragraph form, much like the format for the
rest of this book.
```

```
    Your boss may request that a
synopsis for a book be double-spaced
and in paragraph form, as are book
manuscripts themselves. Your final
product will look something like this
paragraph.
```

Write the synopsis in the present tense, as in, "This happens, then that happens," not, "This happened, then that happened."

The first time you mention a character's name in the synopsis, type it in ALL CAPS. If you are not doing a separate character breakdown (see Chapter Five) you may include a brief description of the main characters in the synopsis. Mention age, appearance, and a note or two about background.

WRITER'S BLOCK

Sometimes when you sit down to write you may suddenly be seized with an illness peculiar to writers known as "creatophobia" or Writer's Block. This condition is characterized by an unreasonable sense of anxiety in the presence of a blank page or computer screen. The experience is similar to the feeling you get when you try to shift a

standard transmission into gear without first engaging the clutch.

The opening sentence is usually the one that causes writers the most grinding of gears. If it happens to you, don't panic. This is normal.

My favorite two methods for overcoming the problem are:

- Write anything, secure in the knowledge that you will edit later. Very few people come up with the perfect words right away. The first sentence is just priming the pump, so to speak. In severe cases, it takes several sentences to prime the pump. Just keep writing! Get the basics down, and do the fine-tuning later.

- Start with the second sentence or paragraph and return to the opening later. Or write the ending first. Start wherever feels good, wherever you already know what you want to say.

I use these techniques whenever I'm stumped for words, not just at the beginning of a piece. They always work.

CHAPTER FIVE
CASTING FOR THE MOVIES
THE CHARACTER BREAKDOWN

The character breakdown is not a nervous disorder as the term implies. It is basically a list used to assist in casting. Talent agencies will be the type of companies most often requesting a character breakdown.

The length of the list is normally around half a page. As with everything else in this business, however, there are exceptions to the rule.

- If you are covering the script for casting in general, you may be asked to include every speaking role no matter how small. Lists like this can sometimes be several pages long.
- If the script has been submitted for a particular actor or actress, usually you will list only leads and co-stars, though occasionally supporting roles will be requested as well.

- If you are covering a book that is either unpublished or that is not yet in development, you may be asked to list leads only.

The "billing" in your character breakdown follows the typical hierarchy of billing in a movie. List the characters in the following order:

1. Leads
2. Co-stars
3. Supporting roles
4. Minor roles
5. Cameos

Often there will be only one lead, male or female, around whom the story revolves. If the lead has a love interest, even if it's a much smaller role, that's the other lead. If it's a buddy picture, the two men are co-stars. In the "female buddy picture" **Beaches**, Bette Midler and Barbara Hershey played the two co-starring roles.

A cameo is a tiny role, usually only one scene. Sometimes well-known actors will take a cameo role if it's juicy or if the movie excites them for some reason - art or money, for example.

For each character you will typically include, in the following order:

1. Name
2. Age
3. Physical appearance
4. A brief description of personality or background
5. The number of the page on which the character first appears

Organizing the description this way makes casting easier. By going from the external (age, appearance) to

the internal (motives, thoughts, feelings, and background), agents and casting directors know at a glance what the role requires. If they see "AMANDA BELLWOOD. Late 20s/early 30s..." they won't be needing head shots (photographs) and resumés for men, after all.

> Try taking notes for character breakdowns while writing the synopsis. Though you won't re-read page by page, you will probably thumb through the manuscript as you go. Thus, the first mention of the main characters will be readily available, complete with full names, descriptions, and page number, saving you time in searching for the information later.

Be precise. Follow closely the writer's description of a character, especially when it comes to the obvious physical characteristics. Sometimes you may even want to quote the writer verbatim.

Suppose on page four of a script, a character is introduced as "MASON BILLINGS, 40ish, balding with a patrician face. There is a hint of sorrow in his eyes even when he smiles." Of course you could write in your character breakdown:

MASON BILLINGS. Late 30s/early 40s. He's losing his hair. He has a noble face and a slightly melancholy air. (4)

But why change it? At the very least, why change "40ish"? It's short and sweet.

By the way, in the example, (4) is the page number where Mason first comes into the picture.

What does Mason do for a living? What are his hobbies? What are his needs, desires, and conflicts in the story? How does he handle trauma? You can add some of this information to your description.

Suppose as you read the work, you find out Mason married his childhood sweetheart right after college, but she died in a plane crash nine years ago. Mason has never remarried. He'd like to, but he has never met the right woman. Suppose you then discover that Mason's father is recuperating from a recent heart attack. It would make sense that as the story opens, Mason is worried about his father but relieved that he at least survived the heart attack. Mason is also ruminating on his own mortality, as well as grieving anew for his dead wife. Hence the hint of sorrow in his eyes even when he smiles.

In Mason's case, your final product might look something like this:

MASON BILLINGS. 40ish. Balding, with a patrician face. He's a therapist. He plays chess once a week with his ailing father. He is good-natured, dedicated, but melancholy. He lost his wife in a plane crash nine years ago and hasn't remarried. (4)

Creativity isn't totally out of the question, but beware of the slightly different meanings of words. "Balding" does not mean totally bald. If the powers-that-be want to cast

someone in the role who is totally bald, that's their prerogative, not yours.

If the writer describes a character using a word you don't understand, look it up in the dictionary. If you can't find it in your dictionary, quote it directly. Don't mess around with someone else's characters. If you don't like them, you can always write your own script!

CHAPTER SIX
SPEAKING YOUR MIND
EVALUATING THE WORK

Why does one story move you while another leaves you cold? Why does one film mesmerize you while the person sitting next to you is more interested in the popcorn? When you recommend a movie to your friends, can you tell them why you liked it?

As a professional story analyst, you'll go beyond saying, "I loved it" or "I loathed it." You'll back up your reactions with reasons in the **comment** or **analysis** section of your coverage.

Your mission will be to point out the potentials and the limitations of the work in question.

The length of this chapter may be misleading, since your comments usually will be limited to between half to three-quarters of a page. But there are many elements that make up a creative work, and you must have a basic understanding of all of them.

Since you have so little room for comments, you will focus primarily on plot, characters, dialogue, and structure in your discussion. Also address comments to concept, writing style, and pace. Then add any other relevant remarks depending on how much space you have left.

Organize your comments in a sensible way. All aspects of a piece of creative work are related, but some are more closely connected than others. For example, comments about subplots go well in the same paragraph as comments about plot. Pace and structure are strongly allied. Concept could be discussed along with plot or probable audience.

The following discussions of major and minor story elements are good starting points for writing your comments. Though the fundamentals are covered, the scope of this book precludes a comprehensive course in how to write a screenplay or novel. Instead, the goal here is to teach you how to discern if a *writer* knows how to write. The two are close kin, but for more about how to write, see the suggestions for a reader's education in Chapter Two.

LOG LINE, PREMISE, THEME, CONCEPT

The terms log line, premise, theme, and concept are often used interchangeably. They usually refer to the central idea or topic, the bare bones of the story line which can be expressed in one or two simple sentences. However, confusingly enough, "theme" and "premise" are also used at times to refer to the underlying message the writer hopes to convey.

Therefore, some definitions are in order.

For our purposes, "concept" will refer to the central idea or topic, while the "log line" consisting of one or two sentences is used to reduce the concept to its bare essentials. "Premise" and "theme" will refer to the underlying message.

For example, the concept for the film **In Country** could be expressed in a log line as, "A young girl's search for knowledge about her dead father forces her uncle, a Vietnam veteran, to come to terms with his own war experiences." The premise could be expressed as, "In facing the past, we gain strength for the future."

Almost invariably, you will be asked to write a log line, which usually appears on your cover sheet (see Chapter Seven.) Whether you include a reference to the premise in your comments is up to you. If the underlying message strikes you as being important to your employer's understanding of the work, mention it.

Consider the following points in discussing the concept and premise:

Originality. Is the concept original or a copy? Is it bold or humdrum? Does it excite your imagination? Is it entertaining? Is it profound? Is it a mafia movie just like **The Godfather**? Is it off-beat, like **The Adventures of Buckaroo Banzai Across the Eighth Dimension** or **Earth Girls Are Easy**?

Is the premise strong? Whether you agree with the premise or not, does it go beyond being entertaining to express a statement of values, or the writer's vision as to the meaning of human life? If so, what is that vision? Is it a

universal theme that would appeal to a large audience, or is it narrower in appeal?

High concept or soft story. The term "high concept" is actually something of a misnomer that's been running rampant for quite some time in all areas of the entertainment industry. A basic, simple idea that's provocative, obvious, and can be expressed in one or two catchy sentences is considered "high concept." This makes for great log lines and sales pitches, not necessarily pithier stories. Examples might be:

"An inventor shrinks his and the neighbors' kids by accident" in **Honey, I Shrunk The Kids.**

"A computer whiz-kid breaks into the government's military computer and almost starts a war" in **WarGames.**

"A robot develops a human personality and escapes from the lab" in **Short Circuit.**

"Soft" stories raise more complicated issues. They tend to be about people and relationships. **Terms of Endearment, Tender Mercies,** and **Jean de Florette,** for instance, are more difficult to sum up in one catchy sentence without losing a lot of the depth, mood, and meaning in the story.

PLOT OR STORY LINE

Predictability. The prevailing attitude among most industry professionals is that there are no new plots. Every story has been told before in one way or another. After you've covered a few dozen projects and seen as many movies, you will no doubt agree with this assessment. You will also be so seasoned and well-informed that you will begin to be able to predict what's going to happen in the

majority of stories with greater accuracy than the "average" movie-goer. Bear in mind that what is predictable to you may not be predictable to someone less experienced than you.

Identify the main conflict, how it is introduced, and how it is resolved. Have you heard the same story before a hundred times? What, if anything, makes this story worth telling again? Is it told from a new angle? Are the characters fascinating? Is the setting unique? Is the work written by formula or with a genuine voice? Is the plot contrived or does it flow naturally? Is it standard material or fresh?

Obstacles, complications, reversals, and twists. These are usually stumbling blocks for the protagonist. They are often turning points as well, causing a sudden change of direction in the story line.

Are there enough complications or surprises to keep your interest high or do you know exactly what's going to happen next? Even though in many Hollywood movies the "good guys" frequently and predictably win, are there enough twists to make you wonder how they'll pull it off? In **Lethal Weapon 2**, the stakes are so high and the danger is so great, we are not quite sure our heroes will survive. In the final battle, it looks as though Martin Riggs actually gets killed. With relief we find he will live, and we merrily leave the theatre hoping for a **Lethal Weapon 3**.

On the other hand, are there too many twists, so that they become boring, ridiculous, or unbelievable?

Which brings us to:

Believability. Is the story something that could really happen? Is it something that could happen given a certain situation and set of rules, as in science fiction or fantasy?

Some of our great classics change the rules believably: **Alice in Wonderland, The Wizard of Oz, 2001: A Space Odyssey.**

Comedies often take place in their own unique worlds where the laws of nature or parameters of social interaction are slightly skewed.

Are you having so much fun you don't care if the story is believable?

Subplots. There are several ways writers use subplots.

A strong subplot mirrors the main plot in some way. It presents a similar conflict from a different angle, from another character's perspective. It becomes a counter-theme of sorts, underscoring the message of the premise.

However, what passes for a subplot in Hollywood is usually a lot less demanding of the audience. For example, there is the standard "romantic subplot." In such films as **Top Gun** and **The Big Easy**, the main ambition of the hero is not to have a love relationship but to achieve something else. In **Top Gun**, the hero wants to excel as a pilot. In **The Big Easy**, the hero wants to solve a crime. Behold, who should appear as each hero's nemesis but a female who is, of course, startlingly lovely? The leads are attracted to each other despite their antagonism, and you can guess the rest. In a formulaic script, this device often plays like a detour from the main journey at worst, or an entertaining side trip at best. Sex sells, but it isn't much of a subplot.

Subplots can also be used to provide comic relief.

Pinpoint subplots, if any, in the works you cover. Are they introduced clearly? Do they make the story more involving? Do they reflect the conflict in the main plot?

Do they have an effect on the outcome of that conflict? Do they affect the hero? Do they genuinely arise from the characters involved? Are they resolved before the credits roll? If the answer is no to any of these questions, the subplots either need to be reworked or omitted.

The hook. Is there anything that grabs you about the story within the first ten pages or so, that makes you want to know the outcome? This is the "hook."

Perhaps it's a certain character or problem with which you identify or which excites your imagination. Perhaps it's a mood or a setting.

If you get hooked, do you stay hooked or lose interest somewhere along the line (no pun intended)?

Continuity. The need for continuity arises on many levels in a film. Every action has a reaction.

Plot. Continuity in the plot means that the questions raised are answered in the course of the story. The writer follows through. Some people call this the "pay-off."

As the story unwinds, does the hero meet the conflict, face the challenges? Does the ending resolve the issues presented in the beginning?

Structure. Continuity is related to structure as well as plot. Are scenes presented in a logical order that develops the story? "A" happens, which causes "B" to happen, which causes "C," and so on.

I once read a couple of scripts by a talented writer who had a skill for creating interesting characters. Unfortunately, he had a tendency to introduce a few very carefully, then drop them completely. They turned out to have no purpose in the story. He did the same with intriguing subplots: he'd introduce one and then it would mysteri-

ously disappear, with the outcome unresolved. This writer, for all his skill, wasn't paying attention to continuity.

Props and settings. Continuity can also be as simple as making sure props and settings are logically placed from scene to scene. This is ultimately the province of set decorators, art directors, and script supervisors, but writers need to pay attention to it as well. For a simple example, if a character opens a door, either the wind blows it shut, or someone closes it, or it stays open throughout the scene until we cut, fade, or otherwise move on to the next scene. Doors don't shut by themselves except in horror stories.

Characters. Continuity is important in character development, as discussed in the following section.

CHARACTERS

Good character development makes a story more than just a plot. In fact, plot arises from character. As a rule, people do things, things don't do people. Also, human beings are interested in what happens to other human beings. A merely well-crafted or unusual plot isn't enough to make a story great.

But what makes a character great?

Some writers think it's enough to throw in a couple of mannerisms, quirky habits, or minor details about a character. For example, they'll create someone who's trying to quit smoking and therefore munches on carrot sticks in every scene. And of course, there's the ever-popular "detective with a pet cat." (This detective usually plays blues piano or saxophone as a hobby, and man, is he good! But I digress.)

Such details can embellish and add realism to a story, but they aren't enough to make a character truly well-developed. Three-dimensional characters resonate throughout all of their actions and dialogue. They draw you into the story. They are always "in character." They experience subtle undertones of feeling and thought that aren't always stated outright in the text. An actor might refer to this as "subtext." It's as if you're reading between the lines in a script and finding something there besides a blank space.

When characters display mannerisms, ask yourself if these arise from within the character or if they seem pasted on as an afterthought. Suppose a character is trying to quit smoking. Why? Did a relative just die of emphysema, perhaps, arousing a heightened fear of death and awareness of mortality? Suppose the character is male. Has he suddenly adopted a regimen of health because he recently got divorced and he wants to be attractive to women? He is also jogging every day now, working out with weights, and eating sprouts at every meal. In what other ways does this affect his personality? Is he cranky or is he a cheerful, bouncy convert to a new lifestyle? Think how annoying converts can be! This character is probably getting on all the other characters' nerves.

Great characters are created by writers who have done their homework in the following areas:

Background. Characters are affected by their physical attributes, their environment, and their experiences from childhood up through the "present" during which the story takes place. This includes their family lives, social lives, friends, enemies, education, jobs, and hobbies. The details

may not be described in words, but the writer knows the character's background. The writer knows the character's drives and desires. The writer knows what the character will do in a given situation.

A good writer reveals the relevant character traits at the appropriate time in the story.

The writer also knows how the character got into the situation that opens the story. Some people call this the "back story" or "ghost," meaning the things that happen off screen, before the tale begins. This is sometimes revealed through the device of flashbacks or through dialogue. We learn something about a character's past that answers one question and raises another. When the second question is answered, a third question is raised.

Casablanca is a perfect example of how back story can be revealed a little at a time. Soon after Ilsa (Ingrid Bergman) appears in Casablanca, we discover she and Rick (Humphrey Bogart) knew each other in the past. But where, when, how? They don't tell us right away. Later, in a flashback, we learn they were lovers in Paris. They planned to flee the city together when the German army invaded, but Ilsa never showed up at the train station to meet Rick. Why? The flashback ends and we have to wait to find out.

Later in the film, Ilsa reveals she was married. But why didn't she tell Rick in Paris? The obvious answer isn't necessarily the right one. Again, we don't find out immediately. This slow revelation of events draws us deeper and deeper into the story. (**Casablanca** also displays excellent interweaving of plots and subplots.)

Range of emotion and expression. Like real people, three-dimensional characters have physical, emotional, men-

tal, and spiritual lives. Like real people, they respond to their experiences on any or all of these levels at different times during a story.

In addition, the intensity of their responses varies. For example, a character might be miserable or merely melancholy, pleased or downright ecstatic, enraged or only annoyed.

Ask if the characters in a work express a range of emotions and thoughts or if the story plods along at one emotional pitch.

Motivation. What do your protagonist and antagonist want, and why? How badly do they want it? If their desires aren't strong enough, the story will lack forward movement. If the characters don't care deeply about something, the audience won't care either.

What happens to prod the characters into taking action? How do they respond to obstacles? How do obstacles and complications force the characters to try even harder, strengthening their desires? If there are no obstacles, there is no conflict in the story.

Furthermore, well-rounded characters have inner conflicts in addition to external ones. They have self-concepts, morals, and values, though they may not be consciously aware of them. They have subconscious drives and needs as well. These hidden elements all relate to motivation.

As you read, ask what kind of people the characters think they are. How do they attempt to bolster their own self-concepts? How do others perceive them? What happens in the story to challenge their beliefs? What do they discover about themselves as the story unfolds?

Fatal and other flaws. Perfect characters are annoying to most people. Whenever you run across a character who never makes a mistake, who always says and does the right thing, you've probably found someone the audience will loathe. You've also found a writer who hasn't created a realistic, believable character.

Great heroes are like human beings, meaning they are like us: they have weak points in addition to their strengths. We appreciate characters in spite of and sometimes because of their flaws. (A fatal flaw, of course, leads to the character's downfall and death.)

These criteria concerning weaknesses and strengths apply to the development of believable opponents as well as heroes: well-rounded antagonists are not all evil; they have their good qualities as well. The main requirement for antagonists is simply that they be in conflict with the heroes.

A strong plot presents conflicts that expose or test the hero's weak points. Who does the exposing and testing? The antagonist.

Evolution. In the course of the better stories, main characters evolve or mature. Again: every action has a reaction. Characters must meet the conflict. The most well-developed characters are changed in some way by that confrontation. They don't remain static.

Consistent development. Well-defined characters are true to themselves. Even a weak character will stand true: he or she will always be weak unless and until enough circumstances arise to cause the character to change. Furthermore, a character who is developed consistently won't be wimpy in one scene and suddenly macho in the next. A

jump like that would be inconsistent unless the character is psychotic. Even if the character is psychotic, the illness might be shown to develop over time.

Rooting interest. What makes you care what happens, so that you "root" for the character to succeed? What makes a character likeable, sympathetic, or fascinating? What kind of audience will identify with the protagonist?

Sometimes a writer chooses to create an anti-hero for the lead, as in **Raging Bull** or **Taxi Driver**. Rooting interest is much harder to arouse in such instances. That doesn't mean the story is no good. It just means this aspect of it may alienate people in the audience to varying degrees.

It is usually easier to create rooting interest by focusing on a single protagonist, but the rise in popularity of buddy pictures and ensemble pieces such as **Rain Man** and **The Big Chill** proves that a single hero isn't essential to a good story.

Rooting interest is strongly related to the "stakes," which are discussed later in this chapter.

The spice of life. Are the characters all alike or is there enough variety to add to the believability and the conflict? For example, some scripts are plagued with characters who all talk the same way. (They probably talk just like the writer, in fact.)

How do the different characters interact? What are the dynamics of the various relationships between them all?

The proof of the premise. Is the lead character the right one to prove the premise of the story, i.e., to carry the conflict through to its conclusion and to get the mes-

sage across? Should a different type of character have been chosen?

Also consider whether all the characters are there for a reason. If they aren't essential to some aspect of the story, they shouldn't be included.

"Role-playing." What kind of talent would this work attract? Does the story have a role that would appeal to a particular actor? Remember, not all movies are blockbusters with megastars in them.

Exceptions to the rule. In comedies, flatter characters and even caricatures are more acceptable than in serious dramas. Action-adventure movies also tend to have less well rounded characters because the emphasis is, after all, on action.

> Bearing the preceding variables in mind, ask yourself if the characters in a given work are three-dimensional or one-dimensional, well-developed or flat (cartoonish, cardboard), fleshed-out or wooden, stock or unusual? These are the standard terms bandied about in the industry when discussing character development.

By the way, though it's unfortunate that it's even necessary to mention something so obvious, the same aspects of good character development apply to all characters, regardless of race, color, creed, or sex. Stereotypes are boring and unrealistic.

DIALOGUE

Good dialogue reveals something about the characters' backgrounds, beliefs, emotions, and desires. It also reveals information essential to the story. The best dialogue accomplishes a great deal obliquely, without baldly stating everything in so many words.

Does the dialogue sound the way people might actually talk? People don't always express themselves in complete, coherent sentences. Is the dialogue appropriate for the characters' ages, backgrounds, educations, experiences, goals? An illustration might be a five-year-old child who sounds like an adult. Is that in keeping with the work in question? Perhaps the child is precocious.

Is the dialogue right for the time period and culture? Do the characters express morals and values relevant to the time and place, and to themselves?

Does the writer use slang or dialects correctly? Slang dates a piece. Dialects and accents are difficult for many writers to recreate believably. Some writers do better to leave the interpretation to the actors. References to time, place, and accent are enough to set the scene.

Do the characters sound alike or do they sound like themselves and therefore different from each other?

Is there too much dialogue, with long rambling monologues or conversations that don't lead anywhere? A script that's too talky often suffers from a slow pace. On the other hand, the lengthy dialogue may be so well-written, we don't find it tedious. **Network** is an example of a talky script that works.

Read some of the dialogue aloud. Is it stilted, wooden, labored, flat, dull? Or is it rich, resonant, and realistic?

Does it flow? Does it make sense? Does it heighten tension and conflict between characters? Does it give away too much or not enough? Does it have a special style? Is it pat or contrived? Is it overblown, melodramatic? Or is it bland and lifeless?

Exceptions. As with characters, dialogue in a comedy doesn't necessarily have to be as realistic or three-dimensional as dramatic dialogue. It does have to be funny, though. Of course, as my esteemed brother once said in all seriousness, "Humor is a funny thing." What one person finds hilarious, another person finds terminally stupid. This is one reason why comedies are among the hardest to predict in terms of success at the box office.

Bear in mind also that if the humor depends on wacky situations or slapstick, the dialogue may not be full of witty one-liners.

THE STAKES

Stakes and rooting interest are intertwined. Yet rooting interest pertains directly to how much we care about the characters. What's at stake in the story has more to do with what the characters want and how likely they are to get it. As a rule, the more crucial the goal, the higher the stakes and the more we root for the protagonists. Continual danger that they may fail also ups the stakes. We want them to win, yet we fear they will lose.

Danger can be physical, emotional, mental, or spiritual. Naturally, the type of danger will relate to the type of story. If you have a story about a love relationship, that love must be tested if drama is to build. The danger here will be primarily emotional and mental, while an action-

adventure without enough physical danger and action has no "pay-off."

Ask yourself what the protagonist stands to lose. How important is it that the protagonist win? What is at risk? Is it life, love, honor, self-esteem, or only next week's paycheck? Is the future of the world as we know it hanging in the balance? How about the whole galaxy, as in **Star Wars**?

STRUCTURE

The traditional structure of a screenplay is in three acts. The first act classically has a turning point or new plot development at the end that leads into the second act. The ending of the second act similarly leads into the third act. These three acts are often described roughly as the beginning, middle, and end of the piece.

But structure involves more than whether a work has a beginning, a middle, and an end. These vague, general terms are used overmuch in discussions of structure. Every work, even the most amateurish, has a beginning, middle, and end of some kind, but are they good ones?

Besides, life is cyclical. Most "endings" signal new beginnings, and "beginnings" must arise from somewhere.

A point Egri makes in his book *THE ART OF DRAMATIC WRITING* is that the beginning is in fact the middle. Something has happened in the past, before the audience comes on the scene, that has brought the characters to the particular place and frame of mind revealed in the opening. This is the "back story" or "ghost," which was also discussed in the section on character development. As mentioned before, important bits and pieces of back story

will be revealed throughout the course of a well-crafted, intriguing story.

Some writers subscribe to the belief that certain events (turning points, climax, resolution, for instance) must take place in a screenplay by a certain page number. Formulas for structure such as these can be used to turn out well-crafted scripts, but they tend to limit originality.

Novelists have more freedom in structure because they don't have the same time limitations screenwriters do. The audience of a novel can pick up the book and put it down at will, while movie-goers sign up for a specific tour of duty, as it were, usually lasting about two hours. The whole story has to be told within that time.

The beginning. The setup usually takes place in the first ten pages, give or take a couple of pages. These ten pages represent the first ten minutes of the completed film. In the setup, the writer reveals who the protagonist is, when and where the story takes place, and to a certain extent, what motivates the protagonist.

Then an event occurs that sets up the main conflict and sets the main character in motion toward a particular goal. This event is called a *crisis* or *catalyst*, also called a *point of attack* or *inciting incident*.

The middle. At its best, the structure of a piece reflects character development. No two characters develop in the same way in the same time frame. Given a specific character with specific goals and desires, a well-structured story unfolds in tandem with the pursuit of those goals and desires, and ultimately, perhaps, with the realization of them.

The middle of a story will contain the evolution of the conflict that occurs once the main character begins to pursue the goal. The protagonist meets obstacles and tries to overcome them. The struggle intensifies.

Many scripts have problems in the middle. How does the writer keep the conflict going and the tension high without making the story episodic, using a series of obstacles and twists that aren't strongly related or believable?

The problem usually results from incomplete character development. The main character doesn't want something badly enough, doesn't have enough direction, lacks an internal conflict to add spice and complexity to the external one, and lacks a worthy, well-developed opponent to make life difficult.

Sometimes a writer develops a story according to a kind of Murphy's Law of Plot Development: whatever can go wrong, will go wrong. This is often used in broad comedies, such as **Parenthood** or **A Fish Called Wanda.**

The end. As mentioned above, the end is often a new beginning of sorts. The audience will have a sense that characters have changed for better or for worse, that they have gone on to new endeavors, that they live on after the final credits roll (assuming they're still alive).

The ending will contain a climax and resolution, meaning the protagonist makes a final play for the goal and either wins or loses. The main problem set forth in the beginning is resolved in some way, even if the future life of the characters seems ambiguous.

Be forewarned that Hollywood has an insatiable appetite for happily-ever-after endings with all conflicts resolved and all loose ends tied up in a neat little package.

This is terribly unrealistic, of course, but that's entertainment.

In sum, ask yourself if the work in question starts at the best moment in the story or if it starts too soon, thereby dragging at the beginning? I have yet to run across a story that starts too late, though I suppose it could be done.

Does the middle follow through? Does it develop the premise? Is the progression from scene to scene scattered or smooth? Does the main character wander, losing sight of the goal or losing interest in it? This would make the middle bland and the pace slow. Does the story unfold logically without being predictable? Does the character's range of emotions jump erratically or grow believably? Within each scene, do dialogue and action build step by step or are they uneven?

Think about whether there is a chance to catch your breath after the climax, or if the story ends too abruptly. On the other hand, does the story drag on and on past the point where the conflict is resolved?

PACE

Pace is most affected by structure, tone, and theme. How quickly do things happen? Is the pace appropriate for the theme and the mood of the piece? Does the story lag or move steadily forward? Does the pace vary, keeping interest high, or does the pace always stay the same? Is it fast when appropriate (fight scenes, for example) and slow when appropriate (romantic scenes, for example)?

Industry folk often refer to the beats of a story as if they were the rhythmic beats of a song. Each event is one beat. "Our hero races to the subway station" is a beat.

"Our hero gets on a train" is a beat. The train ride that follows is a beat.

Has the writer included too many beats? Could we have cut directly to the train ride in this example, and left out the hero rushing to the station? Would we want to leave that beat out considering the tone or mood of the work? Did something happen on the way to the station that added tension or important information?

To help you get a feel for pacing, read an action-packed script like **Robocop** or **Lethal Weapon** and compare the pace and tension levels to a more literary script like **The Great Gatsby** or **Network**. This is also a good exercise in comparing writing styles.

THE WRITING ITSELF

Does the writer have a good command of the language and an ability to communicate ideas and emotions? Does the writer have a personal style and an individual voice? Does the writer know the craft of writing? If it's a screenplay or an unpublished book manuscript, does the writer know the correct format? If not, is it a good enough story to make up for the lack of correct format? (Correct formats are described in Appendix B.)

Does the story rise above the average submission? Is the writing labored or smooth? Is it uneven: sometimes clever, sometimes clumsy? Do the words flow easily? Is the style dense and difficult to comprehend? Or dense and fascinating? Is it dramatic or melodramatic? Is the work too sketchy, leaving important information out? Is the work overwritten, giving more information than can be shown on the screen? A picture may be worth a thousand

words, but a writer can't take that long to describe each visual in a script.

Are there moments that take you out of the story, that make it less involving? If you become so captivated by the story that you forget you're reading a script or book, that's outstanding writing.

Even if the writing is pedestrian, consider whether the concept is strong and original. You may think the story has potential but the writer hasn't executed it well. Or you may recommend the writer but not the particular script in question.

Pay special attention to the writing itself when covering a writer's sample. The industry is hard on new talent and you are expected to be just as hard. There are plenty of good writers already working in this business, and many executives don't have the time, money, or inclination to "break in" or "bring along" new talent. A writer's sample must be way above average before you recommend it to your boss.

AUDIENCE

Will the story reach its intended audience? Consider the age and sex of the people a particular project would attract. To offer a few offensive generalizations, men tend to go for war movies more than women do. Women tend to like films about relationships and romance more than men do. Many teenage boys go for gory horror stories. Who will want to see a film about a kitten and a puppy who become friends? Young children, whose parents will probably be along for the ride.

Will the story be accessible to a wide audience, or does it have the intellectual appeal of, say, a public television production? Does it strike you as a feature-length film suitable for release in theatres, or does it have the feel of a television Movie of the Week (MOW)? A television series? Are there enough characters and plot conflicts to make a miniseries?

Movies made expressly for television differ from feature films in that they are frequently based on emotional topics and current events. They have a more one-dimensional quality in terms of characterization and scope. They tend to be "softer" stories than films destined for the big screen. Sometimes they are based on "true to life" experiences, yet they are often sentimentalized or sensationalized. For instance, how an "average" person overcomes or deals with the "disease of the week" has always been a popular topic for MOWs.

THE BOTTOM LINE

Does the work succeed in its objectives? Is the premise realized? Is the message the writer wishes to convey evoked convincingly?

If it's a comedy, does it make you laugh? If it's drama, does it touch you? If it's horror, does it scare you? If there's a love story involved, is it satisfying when the couple gets together? A good example of the latter would be **Bull Durham**. Throughout the film, the audience wants to see the leads played by Kevin Costner and Susan Sarandon overcome all internal and external obstacles and get together. At last, their wish is granted and everybody's happy.

In deciding whether or not a story succeeds on paper, sometimes you have to trust the writer. In scripts especially, due to lack of room for exposition, if the writer says something like, "Jason and Julie look at each other. A moment between them," accept that this is indeed a special moment. Movie-making is a group process. The director, the talent, the soundtrack, and the many other elements of a film can help make that special moment come alive on screen. The screenwriter is appropriately giving freer rein to the other creative artists who will be working on the film.

On the other hand, the story should be set up so well that when Jason and Julie are said to have that special moment, it works in relation to the rest of the script.

COMPARISONS

Since not everyone has seen every film, it's best not to litter your comments with comparisons to films that have already been made unless:

- they are so well-known that no one in the business could have missed them, or
- the work in question is so similar it might as well have been plagiarized

A reference to genre is usually enough to reveal the nature of the work, as in, "This is an entertaining action-adventure story" as opposed to, "This is just like **Crocodile Dundee**." (See Chapter Seven for a discussion of genres.)

OVERALL REACTION

Finish your comments with your overall reaction to the work and any concluding remarks.

If there is anything outstanding or unique about the work that you haven't discussed already, mention it here.

If the work is a book or play, be sure to mention whether it will translate well to film.

While acknowledging that the future contributions of the director, producers, actors, cinematographer, and the rest of the crew can't be measured from a script or book, is what you've just read a good blueprint for a movie?

Remember that, although you may not like certain kinds of films, other people do. Think about who the audience might be.

Also remember that not all films are box office smashes and they don't have to be. Not all scripts are thoughtful and profound; in fact, sad to say, very few are. It's your job to say whether the work could conceivably make a movie, and if so, what kind of movie, not whether it would be your favorite.

THE GRID

Along with your comments, you'll probably be asked to fill out a grid or table similar to the one presented on the following page. If you have a computer, you can store the form in a disk file. Whenever you need a grid, simply copy the form to a new file, fill in the blanks, and print it out on your printer.

Filling out the grid can be annoying because it is overly general and yet comes across as so conclusive. If you check "pass," it sounds mighty definitive. But the details of your reactions are in the comments, so just grit your teeth and check the closest description in the grid.

	EXCELLENT	GOOD	FAIR	POOR
Characterization				
Dialogue				
Story Line				
Setting/Production				
Structure				
Theme				
Writing Ability				

Budget: low____ medium____ high____
Recommend____ consider____ pass____

> In grid context, "good" usually means great, while "fair" means acceptable. "Excellent" is practically unheard of and "poor" is utterly disastrous. You will probably check "good" and "fair" more often than "excellent" and "poor."

Characterization, dialogue, story line (plot), structure, theme, and *writing ability* have already been discussed in this chapter. Check the appropriate columns.

Setting/production refers to where the story takes place. Is it an exotic or unusual setting, or is it typical? Many stories take place in Manhattan, for example, which may be a great place to visit or even to live, but which is a pretty standard location for a film production. Hundreds of stock "demon raised from the dead" stories take place in abandoned warehouses and subway tunnels in Manhattan. This is so typical, it's substandard.

Check "fair" or "good" for obvious settings depending on how well they weave into the rest of the story. If the setting adds something special to the mood and plot, check "good" or even on rare occasions, "excellent."

Budget. The number of films that make a lot of money at the box office is relatively low. There are video and foreign rights to consider, but many motion pictures lose money or barely manage to break even. In fact, the standard prospectus for investors in motion pictures warns repeatedly that investors *will* lose money; no ifs, ands, or buts; no promises of glory and riches.

This is not surprising when you consider the typical Hollywood film budget these days ranges from about eighteen to twenty-five million dollars. That's a lot of movie tickets to sell, even at seven bucks a shot. Therefore, budget considerations are an inescapably important factor in whether a project goes into development.

Readers aren't expected to break down the budget for a film, but it's helpful to have a rough idea of costs.

A low budget film usually takes place in one or two locations. There might be a car chase or two, but no special effects. Plenty of excellent "low budget" films have been made by independent film-makers, meaning directors, writers, and producers who are not allied with a major studio or production company.

A high budget film will contain one or more of the following:

- many locations, possibly many continents
- pyrotechnics (explosions)
- special effects (science fiction is usually expensive)

- scenes taking place on or under water
- aerial photography
- large scale period pieces (with period costumes and settings, as in **Dangerous Liaisons** or **The Last Emperor**)
- stars, superstars, or megastars who command a high salary per picture

On the grid, you will most often check "medium" or "average" for budget.

Recommend, consider, pass. Whether you check recommend, consider, or pass will depend to a certain extent on who your boss is and the purpose of your coverages.

Recommend those scripts and books you absolutely LOVE without question or reservation.

Pass on the projects that you find thoroughly disgusting with no redeeming merits whatsoever.

In general, if you're working for a talent agency, consider everything else worthy of consideration. Maybe the characters are intriguing but the story line is trite. Say so in the comments and check "consider." Maybe the concept is good and would adapt well to the screen, but the writing is awkward. Say so in your comments and check "consider." You can even recommend that the script be sent back for a rewrite or that another writer be attached. (Book authors shudder in horror at the very phrase, "attach another writer." This practice is inconceivable in the world of book publishing when it comes to original work, but such are the realities of the film industry.)

Talent agencies usually expect you to check "consider" more often than "pass" or "recommend," since agen-

cies usually have an "A" list and a "B" list of talent for whom they are seeking projects.

When working for a studio or production company, you will probably pass on the majority of scripts. You will be much more conscious of the budget, the risk, and the volume of submissions. Since these are the companies that shell out the money to make the films, they tend to be very picky about the ones they choose to produce. You may not always agree with their criteria, but it behooves you to be aware of their preferences.

Suppose you work for a motion picture production company, and suppose that company receives fifty script submissions a week. That's two thousand and six hundred scripts a year. Suppose that same company produces ten movies a year. It's easy to see that the odds against a given script actually being made into a film are enormous.

Which of the works you cover merits being one of the ten your boss will produce? If you come across one that really makes the top ten of all the works you've read, recommend it.

What story editors look for in a project:

- good characters
- good writing
- a strong story
- humor
- an off-beat story or a new perspective

OPINION VS. EVALUATION
Writing Effective Comments

All opinions are subjective. Everyone has an opinion. Not everyone agrees. What makes your opinion worthwhile?

The technical tools discussed in this chapter for assessing a project will help you to be as objective as possible. You will be able to back up your opinions with hard knowledge, making them professional evaluations.

Your evaluations will have more credibility if you develop an effective style of communicating them.

Getting to the point. Usually, if you like the work, you'll begin your comments with a positive tone and then point out any weak areas in a later paragraph. On the other hand, if you don't like the work, you may as well let your boss know up front.

Getting personal. Don't. As is obvious to you by now, readers are in some ways critics, and since many readers are also writers, they can be harsh critics indeed. However, direct criticism of other writers is bad form and unprofessional. Concentrate on the work you're covering, regardless of whether or not the writer is well-known, regardless of how you feel about his or her previous work. Address your comments to flaws and flairs in this one particular piece.

Saying, "This writer couldn't write his way out of a soggy paper bag with a fine point pen" expresses your opinion but doesn't say a thing about what is wrong with the script or book. Stay focused. If it's boring, why is it boring? Is the plot typical of dozens of other movies you've seen? Are the characters flat? In what way? Say what you

think, but leave the writer out of it. Your boss wants to know about the work itself and will appreciate your ability to address the important issues.

Getting impersonal. Some companies prefer their readers to write comments from a completely clinical, objective stance. This is saying what you think while making it sound like an impersonal authority. Other companies don't mind hearing your personal voice, as in "I found the low-brow humor offensive" versus "The low-brow humor may offend some people."

You will soon learn what your employer prefers, but so long as your comments are informed and intelligent, most people won't find the use of personal pronouns offensive.

Getting tough. Whether you use the "I" word or not, don't be afraid to take a stand. Words and phrases like "somewhat, often, seems, appears to be, a bit, now and then, more or less, occasionally, fairly, faintly, slightly, a little," and so on are wishy-washy or "soft." I frequently (yes, that's another one, but it's appropriate here) have to edit them out of my own writing.

Of course, the writing in many projects is uneven. For instance, the dialogue may be stilted in places but not all the way through. Learn to distinguish between the times you are correctly analyzing the pros and cons of a work and the times you don't want to make a broad, definitive statement for fear someone will disagree with you or you'll lose your job. Back up your evaluation with technical knowledge and examples, and delete your "hedging words."

Getting cute. Witticisms and sarcasm are sometimes hard to resist, but they are usually both out of place and underappreciated by the higher-ups. Certainly leave the clever asides out of sample coverages, while you're still looking for a job.

WHAT SELLS

Recently a successful director whose popular movie was still playing theatres around the country submitted a new script to the same company that produced the hit.

The nightmare is, the head of the company passed the new script on to a lowly reader (standard procedure).

The dream-come-true is, the reader loved it!

The nightmare is, still the company rejected it.

The two-pronged moral of the story is, there's no predicting what will sell, and even when someone is already successful, they don't always get special treatment.

As you pass sentence on someone else's work in your comments, it helps to remember that in life, unlike in many stories, nothing is predictable. It's common knowledge that **Star Wars** was turned down all over Hollywood because of the widespread belief that women wouldn't want to see a science fiction movie. Wrong.

The best anyone can do is to be aware of the trends and make educated guesses. Sometimes we're right, sometimes not. Therefore, your informed opinion is as good as anyone else's. Express it well and you can have a strong career as a reader.

CHAPTER SEVEN
VITAL STATISTICS
WRITING THE COVER SHEET

For quick reference and filing purposes, companies keep a log of all or part of the following information, which you will type either on a separate **cover** sheet or at the top of the first page of your coverage.

COMPANY NAME:	TITLE:
AUTHOR:	FORM:
DRAFT:	PAGES:
GENRE:	TIME:
LOCATION:	SUBMITTED FOR:
SUBMITTED BY:	ELEMENTS:
PROJECT STATUS:	COVERAGE REQUESTED BY:
ANALYST:	DATE:
LOG LINE:	

As with the grid, if you have a word processor, you can store these headings in a computer file and copy them

each time you need them. Otherwise, your employer will give you a form you can fill in using your typewriter.

Some of the necessary information will be provided by your employer, while the rest you will discover from reading the work. If requested information is unavailable, put a couple of dashes (--) or "N/A" for "not available" in the relevant slot. This shows you omitted the information because it wasn't given, not because you made a mistake.

Copy the title, author, form, draft, number of pages, and when applicable, who is submitting the work directly from the script or book itself, not from a cover sheet handed to you by anyone else. Errors occur in transcribing; to typo is human; use the original.

COMPANY NAME

This is obvious: put the name of the company that hired you here.

TITLE

This is also obvious: put the title of the work here.

AUTHOR

Include the writer or writers as well as the names of any contributors. For example, you will sometimes see a script title page that reads something like:

<div align="center">

THE MAZE
by
T. L. KATAHN
Story by Patricia Lipman
Additional material by Mom and Dad

</div>

Include everyone and what they did under "author." Everyone likes to get credit, and besides, for all we know, Mom and Dad are famous and your boss wants to know their names.

FORM

Form will usually be "screenplay" or "novel," though sometimes you will cover other forms (see Chapter Three).

DRAFT

"Draft" means which version of the work is being covered. For instance, sometimes the title page of a script will include "2nd draft, revised May 19, 1990." Sometimes there will merely be a date.

For unpublished books, you may simply write "manuscript" in this space. For published books, include the publisher name and the date of publication, as in "Published, W. W. Norton & Company, 1986." Sometimes a separate space will be provided for PUBLISHER/DATE.

PAGES

Pages means the length of the work. The average script is around a hundred and fifteen to a hundred and twenty pages these days. Novels are usually around three hundred to three hundred and fifty pages.

GENRE

Use genre to help describe the nature of the work. Pick from the standards or, if what you've read doesn't bear pigeonholing, combine genres. You can even make up your own if necessary. "Female buddy picture" is a

fairly new one, for example. To carry this to absurd lengths, **Who Framed Roger Rabbit?** might be described as an "animated/live action detective comedy." It just doesn't fit a typical niche.

Here is a list of some widely used categories along with some examples in film and television, many of which are obvious in the interests of being thorough.

Genres	*Examples*
Action-Adventure	Indiana Jones movies
	Romancing the Stone
Animation	The Little Mermaid
Biographical	Eleanor and Franklin
	Bird
Black Comedy/Satire	Network
	Heathers
Broad Comedy	Airplane
	A Fish Called Wanda
Buddy Picture	Rain Man
Business	Wall Street
Children/Juvenile	The Muppet Movie
Classroom Drama	Stand and Deliver
	Dead Poet's Society
Comedy Fantasy	The Princess Bride
	Earth Girls Are Easy
Comedy Thriller	48 Hours
	Lethal Weapon 1 & 2
Coming of Age	The Breakfast Club
Courtroom Drama	Nuts
	Perry Mason
Crime Drama	The Untouchables

Genres	*Examples*
Detective	Colombo
	The Maltese Falcon
Disaster	Airport
Docudrama	Echoes in the Darkness
Documentary	Joseph Campbell and the
	Power of Myth
Drama	The Mission
Ensemble	The Big Chill
	thirtysomething
Erotica/Sexual Obsession	9 and ½ Weeks
Family Appeal	Honey, I Shrunk the Kids
Female Buddy Picture	Beaches
Holocaust	Testament
	The Day After
Horror	Friday the 13th movies
Love Story	Love Story
	The Way We Were
Musical	The Sound of Music
	Tommy
Period Piece	Dangerous Liaisons
	A Room With A View
Police	Miami Vice
Prison	Weeds
Road Picture	Easy Rider
Romantic Comedy	When Harry Met Sally. . .
Science Fantasy	Brazil
	Beauty and the Beast
Science Fiction	2001: A Space Odyssey
	Star Wars

Genres	Examples
Situation Comedy (SitCom)	Roseanne
	The Cosby Show
Sports	Eight Men Out
Spy/Espionage	James Bond movies
Suspense/Thriller	Wait Until Dark
	No Way Out
War or Military	Platoon
	An Officer and a
	Gentleman
Western	Young Guns
Whodunit	Murder on the Orient
	Express
Youth Comedy	Fast Times at Ridgemont
	High
Youth Drama	Pretty in Pink

Note that there is considerable overlap in some of these genres. For example, **Powwow Highway** has been described as a "buddy pic," a "road pic," and a "comedy-drama." It has elements of all these genres.

Note also that:

- In buddy pictures, the main characters are usually two guys who can't stand each other but are thrown together against their will in order to achieve some goal. Naturally they become great pals.
- Docudramas are dramatizations based on true life stories and are not to be confused with documentaries, which are more like news reports and are not supposed to be fictionalized.

- Science fiction is futuristic and is characterized by outer space, special effects, and hardware, like spaceships and computers. Science fantasy is often futuristic as well, but is less technology-oriented and concentrates more on "alternative worlds." It's "softer" than sci-fi.
- In a "coming of age" film, a transition of some kind to maturity of some kind is usually shown. This is probably easily confused with a "youth drama," which may show less of a transition.
- The popularity of genres ebbs and flows. Disaster films are out as of this writing. Thrillers, action-adventures, and comedies are hot. Any film having to do with baseball was considered dreary until **Bull Durham** came along. Be aware of the trends in the marketplace, but be aware that trends change. If you read a great story in a genre that is currently unpopular, let your employer know you're bucking the trend, but go ahead and recommend it. Take a stand.

TIME

Note when the story takes place.

LOCATION

Note where the story takes place.

SUBMITTED FOR

Work might be submitted for possible representation for the writer(s), for casting, or for packaging. Mark this section accordingly. Or, if the work has been submitted to

a particular actress or actor, director or producer, you will fill in the target person's name under this heading.

SUBMITTED BY

The name of whoever submitted the work to your company goes here. This could be an agency, a production company, a writer, a writer's agent, a writer's best friend... although in the latter case, they probably won't let on they're just friends. (Many companies won't even look at unagented work, so writers must find someone to represent them, a task which is easier said than done.)

ELEMENTS

This might include a director, a producer, casting director, talent, casting agent, and so on. If elements are listed, these are the people who have already agreed to work on the project. They are part of the "package" that is being put together to make the movie.

PROJECT STATUS

A project might be "in development," which means the work is a prime contender for being made into a film. The elements are being sought. Perhaps the script is being rewritten as well during this process.

If project status is a "go," the elements are in place and someone is already pouring money into the production.

I once covered a project that had "available" marked in the project status slot. Budding writers, be advised that "available" is:

- a cry for help
- a giveaway that you're a novice
- more appropriate for the personals column in a newspaper

COVERAGE REQUESTED BY

Fill in the name of the person in your company who asked you to cover the work.

ANALYST

This is you: fill in your name.

DATE

Enter the date you're writing your coverage or turning it in.

LOG LINE

As discussed in the preceding chapter, theme, log line, concept, and premise are often used to mean the same thing: a concise sentence or two outlining the plot.

If you have written a synopsis, writing more than one or two sentences for the log line is redundant and a waste of valuable time, both yours and your employer's. The synopsis is there if anyone wants more detail. Some companies do ask for a lengthier concept or *capsulization*, maybe a paragraph or two. In that case, their wish is your command. Sometimes your capsulization takes the place of a lengthier synopsis.

If you wait to fill out the cover sheet until you have finished the synopsis, character breakdown, and comments, you will probably know the story well enough to come up

with the log line in a matter of moments. Some stories are easier to reduce to one sentence than others, of course, and some log lines can sound dismally trite. After all, this is the plot at its most basic. You can often make up for the inherent triteness by using strong modifiers and action verbs.

Consider that casting agents and other executives must be able to read the log line and immediately get a sense of what talent is appropriate, or what director or producer would be interested in the project. This isn't always as far-fetched as you might think. If your log line reads, "An orphaned kitten and a runaway puppy become friends and pursue a series of rollicking adventures in their search for a good home," a director like Oliver Stone isn't likely to pop into your boss's mind as being perfect for the job.

An exciting log line can help sell a script. Think of it as advertising copy. Pretend what you write will be used to entice an audience to pay to see this film.

Get right to the point: the main conflict in the story and the main character that conflict involves. Though there are exceptions, most executives don't need the ending included here. Give just a taste of what the story is about. Make it catchy but general. Make people want to read more.

Of course, if you don't like the work, you will be less inclined to show it in a good light. But remember, your mission is to look for possibilities. You need not attempt to make it sound better than it is, but be as objective as you can.

CHAPTER EIGHT
THE LAST WORD

You write the last word of your coverage, lean back comfortably in your padded swivel desk chair, scratch your purring kittycat's head, and allow a sweet sense of accomplishment to pervade your being. You're finished, right?

Not quite. As a good ending in a story often signals a new beginning, so it is with writing coverages, if you'll pardon the heightened dramatics of the analogy.

Revising what you write is your new beginning. Editing is also the telling moment when having a word processor is a godsend. If you don't have one yet, save money and get one. As mentioned in Chapter Two, editing on a word processor saves immeasurable time and hassle, and frees you to take on more work. Thereby enabling you to make more money. Thereby enabling you to buy a better word processor. And so on.

If you use a word processor, print out the final rough draft instead of editing everything onscreen. Although you may have software that will check your spelling for you, you'll find errors on paper that you didn't notice on your computer screen and that your computer can't correct for you. Many editing decisions require the personal touch. Plus, there's something about the "hard copy" that makes errors jump out at you.

Print out or type your rough drafts double-spaced. This leaves room for editing marks and insertion of new or revised text. Commonly used proofreader's marks will simplify your editing tasks once you get in the habit of using them. See Appendix D for a list of these standard marks.

> A red or blue pencil is useful for marking corrections that will stand out easily on paper, though I use whatever pen or pencil comes to hand.

HOW TO EDIT

Organize your thoughts. In the synopsis, this will be a piece of cake. You're following the story line and most of the organization has been done for you.

In the character breakdown, make sure you list the characters in order of importance. Then check to be sure that the description of each character is in its logical order as well (age, appearance, personality traits, page where they first appear).

In the comments, check the grouping of the topics you discussed.

There are commonly used rules for paragraph structure in the wonderful world of "normal" writing that you won't use much in writing coverages. In "normal" writing, a well-written paragraph goes from the general to the specific. You start with a topic sentence (the broad strokes of the brush, as it were), then proceed to color in the details with explanatory subordinate sentences.

However, coverage components are so short, you don't have room for many subordinate sentences. In the synopsis, you're only relating the plot, not explaining it. In the character breakdown, you're essentially making a list in paragraph form. In the comments, though you may have a subordinate sentence now and then, you will primarily be supplying the "broad strokes" for each point you discuss. You will have whole paragraphs consisting of nothing but topic sentences.

Be clear and concise. You will almost always find ways to express things more succinctly as you re-read.

First, cut out unnecessary phrases.

Second, beware of redundancies. Don't repeat yourself as I am doing now.

Third, check to see that actions are expressed using verbs rather than nouns. For example, "She makes a plan" is better expressed as, "She plans."

Fourth, use verbs in the active voice rather than the passive, as in, "People do things" rather than, "Things are done by people."

Fifth, keep subject, verb, and object near each other to clarify action. Give your sentences "the comma test": count how many commas you have put between the subject, verb, and object. Then see how many you can remove.

For example, "The creature, seeing the angry humans approaching, runs back, with a howl, into the swamp" works better as, "The creature sees the angry humans approaching and runs howling back into the swamp."

Sixth, as a general rule, express one thought per sentence or clause. Too many activities clutter a sentence and confuse your readers. Consider, "The creature sees the angry humans approaching and runs howling back into the swamp just as young Robbie trips over a tree root in the darkness and falls smack on his face in the slime." There are quite a few people or creatures moving about in that sentence. It might be rephrased as, "The creature sees the angry humans approaching. It runs howling back into the swamp. Young Robbie suddenly trips over a tree root. He falls smack on his face in the slime."

Shorter sentences are becoming increasingly fashionable in scriptwriting. They speed up the pace. To carry it to extremes, some screenwriters have begun to use a kind of shorthand of incomplete sentences. They might write, "The angry humans approach. The creature sees them. Howls. Runs back into the swamp. Robbie trips. Splat! His face in the slime." James Joyce it isn't, but it's visual, it's fast-paced, and it works in screenplays. Remember, we agreed in Chapter Three to ignore improper sentence structure and grammar unless they make the story incomprehensible.

Your coverages will suffer, however, if you overuse this "shorthand" style.

Check for accuracy. Refer back to the work itself as necessary to be sure times, place names, character names, and other details are correct.

Check the mechanics of your work. Correct any errors in spelling, punctuation, or grammar.

Now you're ready to go back to your word processor or typewriter and incorporate into your coverage the revisions you've been scribbling in the margins. The result is your final draft.

RUNNING HEADS

Many people don't care whether you use running heads (headers) or not in your coverages, but it's a small, often barely noticed, yet useful mark of a professional. Running heads help you quickly collate copies, especially if you cover more than one project at a time. You will staple the coverage components together when you're done, but what if the pages are separated by mistake as they make their journey from exec to exec to the file cabinets?

Include page numbers and the name of the work being covered or an abbreviation thereof. You may want to label your coverage components as well, as in "Synopsis/p. 2."

The upper right hand corner is a nice place to put running heads. As people leaf through the coverage, they can see immediately what page they're on, helping them find the section they need at a glance.

Again, a computer is a dream come true: once running heads are typed into your template file, you never have to type them again.

THE FINAL DRAFT

Keep a copy of each of your coverages for yourself, in case you need a sample to submit to another company

someday, or in case you need to refer back to a project for any reason.

A copy of your coverage will be kept on file at the company office. The remaining copies will be circulated among various executives, sometimes even being sent to other companies.

It is true that some employers just want proof that a work was covered. They may file your work with barely a glance. Some executives find the synopsis more useful, while others pay closer attention to your comments. But at most companies, people *will* read what you write. They wouldn't spend money on readers otherwise.

■CHAPTER NINE
GETTING THE JOB

Now that you have the technical skills to be a story analyst, what are your chances of landing a job? Every aspect of the entertainment industry is highly competitive, story analysis included. There is no guarantee that you will get a job as a reader just by reading this book. Yet by following the guidelines suggested herein, you have a number of advantages over your competitors. First, you're better-trained than most. Second, you're going to develop a workable plan that will help you in your job search.

In general, deadline requirements make living in a center for the entertainment industry like New York or Los Angeles imperative if you want to be a reader. There may be a smattering of jobs available in other cities where some film and television production takes place, but New York and L.A. are still the top two places to be in America if you want to be involved in the industry.

Agencies, production companies, studios, and occasionally, actors, actresses, and directors use readers.

Since changes are frequent, establishing a current listing of companies and industry personnel whom you can contact is a full-time job in itself. Therefore, I have chosen not to include such a listing here, as it would soon grow outdated. Luckily, there are several companies that publish entertainment industry directories. These are updated every few months. They provide a far more comprehensive job pool than the yellow pages of the phone book.

> Addresses and phone numbers in this chapter are provided for your convenience. They are current as of this writing.

The following libraries are likely to have current copies of the major show biz directories:

- the Margaret Herrick Library at the Academy of Motion Picture Arts & Sciences, 8949 Wilshire Boulevard, phone 213/278-4313. (Plans are for the Academy library to move as soon as the building for the Center for Motion Picture Study is completed.)
- the American Film Institute, 2021 N. Western Avenue, phone 213/856-7655
- the UCLA Theater Arts Library on the UCLA campus, phone 213/825-4880

You can also purchase your own directories from a bookstore specializing in theatre and film books. In Los Angeles, try Samuel French's Theatre and Film Bookshop

or the Larry Edmunds Cinema and Theatre Bookshop Inc. Or you can order copies directly from the publishers.

The *HOLLYWOOD CREATIVE DIRECTORY* lists hundreds of motion picture and television development and production companies, their executives, and often the names of recent films they've produced. The *HOLLYWOOD AGENTS DIRECTORY* provides listings for talent and literary agencies. The publisher's phone number is 213/208-1961.

DVE Productions publishes similar guides. You can contact them at 213/281-7637.

The *NEW YORK PRODUCTION GUIDE*, the *FLORIDA PRODUCTION DIRECTORY, THE REEL DIRECTORY* for Northern California, and *THE INDEX* for the Pacific Northwest are a few of the directories available for different areas of the United States.

Actors and actresses get tons of script submissions; they sometimes need people to read for them. However, they often have a personal assistant who fulfills that function along with performing other tasks. Though they may start their own film production companies, these are usually small operations geared to finding material for that particular actor or actress as opposed to developing projects for other people. Thus, the development departments are small. Your chances of getting a story analyst job in such a situation are slim simply because the job doesn't often exist.

The *FILM DIRECTORS GUIDE*, published by Lone Eagle Publishing, can help you locate directors. However, the situation with many directors is similar to that of talent;

they may have assistants who help them with the reading they don't have time to do themselves.

THE PUBLISHING INDUSTRY

Though the focus in this book is on story analysis for film and television, you can apply most of what you've learned to reading for the publishing business as well.

One difference between reading for the screen and reading for publication is that, in the latter case, you may be asked to cover books such as technical manuals or other nonfiction. Your coverages will reflect this: comments on plot or character development are necessary only for fictional work or biographies.

You can expect to be paid about fifty to a hundred dollars for book coverages depending on how long or complex the manuscript is.

In many cases, book clubs, book publishers, and literary agents use staff editorial assistants to do the reading, but they have been known to use freelance readers. Most of these freelancers are residents of New York City, the center of the publishing world in the United States. The large pool of local readers and would-be readers makes sending books to out-of-town readers an unnecessary expense and time delay.

If you would like to pursue this avenue, look at the *LITERARY MARKET PLACE*, which lists agencies, publishers, and book clubs you can contact to ask about reading jobs. Almost any library in the country will carry a copy of this reference.

THE BEST APPROACH

There are several ways to approach the job search.

One is to start calling story editors at agencies, studios, and production companies.

Another approach is to send sample coverages through the mail to prospective employers. Include a résumé if you have one and a brief typewritten cover letter saying who you are, what you want, and what special qualifications you have. Avoid making a sales pitch. Executives don't have time to read it, and they are unlikely to believe self-laudatory prose anyway. Besides, your coverage will speak for itself.

Even if you're using an up-to-date directory, it's best to double-check personnel. Call first and ask for the name of the person who hires readers before you submit your sample coverage.

To supplement your attempts by phone or through the mail, be sure to let your friends and acquaintances know you're interested in a reading job. You never know when they'll hear of an opening from one of *their* friends. It isn't essential, but it doesn't hurt to know someone who knows someone. After all, trustworthiness is an important factor in a story editor's decision to hire a reader. If you are an outsider "off the street," you may be competing in some instances with friends of friends who come highly recommended. This is not to defend or pass judgment on the system; it's a fact of life.

Naturally, it can be frustrating when the "buddy system" works against you. However, by living in New York or L.A., you're bound to meet people who work in the in-

dustry and you're bound to become friends with some of them.

The Three P's

Whether you do it over the phone, through the mail, or through friends, the best approach is *having the right attitude*. Yes, that sounds New Age-ish and Pollyanna-ish, and you may think initially that it won't pay off. It's true that being positive and enthusiastic doesn't guarantee you a job. But it helps. A good attitude makes people want to work with you.

There are three personal skills you can develop to help you get a reading gig, all of which have a lot to do with having the right attitude:

- be professional
- make a good presentation
- be persistent

Be professional. Prepare before you call. What will you say besides your name and your desire for a job? How will you say it? What's special about you that makes you perfect for the job?

Mention any related skills you may have: perhaps you're a writer or you've taught English; maybe you have a degree in journalism or you studied acting in high school. Any experience you have in written, verbal, or visual communications will stand you in good stead.

Point out your strengths and preferences, the kinds of movies you like to see, the kinds of books you read. Story editors must learn their readers' tastes. For example, some are good at covering romantic comedies and dramas, while an action script might suffer in their hands.

What if your prospective employer thinks you're over-qualified? Stress your enthusiasm for the job. Why do you want it? Maybe it's a perfect part-time job for you now that you've had a baby. Maybe you hope to write scripts and you want the experience of reading them. Maybe this is a chance for you to learn about the business so you can become an executive or a producer. Express your motivation.

If you're not much of one for selling yourself, write yourself a short script for a phone interview. Create a paragraph offering the above information so you'll have it right in front of you while you make your calls. Then you won't be stumped for what to say next.

Part of being professional is also being pleasant. Movie moguls are people too. Be confident and assertive without being obnoxious and overbearing. Whiners, beggars, and people with chips on their shoulders are also off-putting. You're not desperate for the job, right? On the other hand, you'd really like to do it. You know you can do the job well, right? But on the other hand, you're willing to learn and improve.

Another part of being professional is knowing the realities of everyday life in the business. Many story editors get several calls and letters a week from people looking for reading jobs. If you can't sell yourself in about thirty seconds, you're probably out of luck - that day. So, give relevant information as concisely and pleasantly as possible, realize you're one of many callers, and be prepared to be turned down - that day. You aren't being singled out for persecution merely because there are no openings available - that day.

The presentation. Once you've made contact with a potential employer, offer to do a sample coverage for free. This is often called a "spec" coverage, from the verb "to speculate," which in this context no doubt means "to gamble."

Prospective employers will often oblige you by loaning you a script for your spec coverage.

Using theirs has three advantages over supplying your own:

- Employers will know the script well enough to make a competent, quick evaluation of your coverage.
- You prove you can meet the deadline.
- You may well have a chance to meet them in person.

Nonetheless, it's a good idea to find a script yourself and have a sample coverage prepared before you call. If the story editor doesn't have time to meet with you and give you a sample script, you can mail your own coverage or drop it off, thereby giving you an alternate way to get your foot in the door.

The libraries mentioned earlier in this chapter are good places to look for scripts to cover on your own. These libraries are archives for film scripts, from classics to recent films. You are not allowed to check scripts out or photocopy them, but you may read them and take notes on the premises.

Or ask around. A friend might know someone who has a script you can use for your sample coverage.

You can also buy a well-known movie script from a company like Script City. This is a much more expensive

way to go, but for those who can't get to the library, it's a welcome option. Write or call for a free catalogue. Their address is 1770 North Highland Avenue, #608, Hollywood, CA, 90028. Their phone number is 213/871-0707.

If you find a story analysis class that interests you, you may have an opportunity to write a coverage there. But many story editors can spot a classroom-generated coverage a mile away. The format used and the type of language fostered in a classroom setting are dead giveaways. This isn't always a drawback if your coverage is well-done, but it is a clue that you are new and inexperienced. Write a few coverages before selecting the best one to submit as a job-hunting sample.

You may want to submit several coverages, including perhaps a "recommend," a "pass," and a "consider."

Or you may choose to submit two coverages, one of a book and one of a script. It's advisable not to rely solely on a book coverage, since this is the film industry and you'll need to show that you know your way around a screenplay.

> Warning: Writing a spec coverage can be a stumbling block. Some would-be readers take home a company's sample script and never return with a coverage. Maybe the pressure's too much for them. A key point to remember is not to get too anxious about your writing. Just put the words on paper; say whatever comes to mind, in fact. You can revise later.

Make sure your sample looks good and reads well. It must be typed, legible, and logical. Check your spelling, punctuation, and grammar.

Almost all readers use a word processor these days; they've become an industry standard. If your only equipment is an ancient manual typewriter, you're at a disadvantage from the moment your work hits someone's desk. It just won't look as good as your competitors' work. If your presentation is sloppy, it will be tossed in the "round file" and you won't get the job.

Be persistent. I encourage you not to give up too easily in your search for a reading job. There is a high rate of turnover in this business. People move up, out, and around. Besides, readers are an eclectic crew. Many of them don't plan to keep reading forever. They want to be writers, producers, executives, or one of a myriad other goals. They may leave to pursue these goals. They may get promoted or transfer to a different company. They may go on vacation during a busy spell, or decide to cut down on the number of coverages they do.

In addition, though a company may have a core group of trusted readers, there are usually a few on the fringes whose work simply isn't up to par. They're liable to be replaced before long, maybe by you.

Consider, too, the daily avalanche of submissions. It often seems that you cover one script only to see two more spring up in its place. As of this writing, an average of fifty to seventy script or book submissions *per week* go through the offices at Triad Artists, Inc. Talent and Literary Agency. Large studios like Twentieth Century Fox are blessed with anywhere from around fifty-five to eighty submissions per

week. Even a small production company like Hometown Films may receive a dozen or more submissions per week.

As you can easily see, sudden and unexpected opportunities arise all the time in a volatile business like this. A rejection one day doesn't mean rejection forever.

If a company doesn't hire you right away, ask politely if you can call back in a few weeks to see if they need anyone. If they still don't need anyone, call again a few weeks after that. Sooner or later they're bound to have an opening. If you're professional, persistent, and make a good presentation (the three p's), you might be the one to get the job.

DEVELOPING A JOB SEARCH PLAN

Those who are instinctive self-promoters may not need much guidance in this area, but others may find that a plan helps keep their motivation high. By setting up a time-table and a logical schedule of companies to call, you set yourself a daily destination that is easy to reach.

Step 1. Decide who you want to call first. The hundreds of companies listed in the directories may seem overwhelming. So let's narrow down the field.

You'll probably want to start with the companies that use the most readers. Large studios employ anywhere from six to twenty readers at a given time. A medium-sized talent agency may have six to eight full-time freelance readers, with several more rotating in and out of the office on a part-time basis.

Make a list of perhaps fifteen to twenty companies. These will include the major agencies and studios whose names are familiar to you. This is your "A" or preferred

list. Even if they don't need anyone right now, they do use readers and you will be calling them back if you don't land a job somewhere else.

Then prepare a "B" list of about twenty to thirty lesser-known companies, including production companies. Be sure to include in this list some companies who have done the kinds of films you enjoy.

Step 2. Set aside a block of time to make calls or prepare your submissions for mailing. Give yourself an hour a day, perhaps, or three hours one afternoon a week, whatever works for you. When your time is up for the day, even if you haven't gotten a strong lead - that day - you can at least pat yourself on the back for accomplishing the amount of work you set out to do.

Some say the best days to call are Tuesday through Thursday. This way you presumably avoid the Monday blues and the Friday rush to get out of the office. The best times of day to call are traditionally considered to be between ten and eleven in the morning and two and four in the afternoon. Your contacts presumably won't be at lunch. However, they are just as likely to be in meetings.

Therefore, in my opinion, the best days and times to make business phone calls are *when it suits you*. Choose the time when you feel most wide awake and energetic.

Work your way down your "A" and "B" lists. First call to find out exactly who is in charge of hiring story analysts. Then ask to be connected to that person, or if you prefer, you can mail in a sample.

Typical responses you might get:

"We don't use readers."

"We don't need anyone right now."

"Send in a sample."

"I liked your sample and I'll keep you on file."

"You're hired!"

Make a note of each response and the date you made contact. Mark an "x" by the ones who don't use readers at all; you're not going to bother calling them back.

If they say they don't need anyone right now, that's great! This means they do use story analysts; they may have an opening in the future. Make a note of it. You'll be calling them again.

Once someone asks for a sample coverage, send it in, drop it off, or offer to do one especially for them. Make a note of the date you deliver or mail it. Follow up with a phone call a week or two later if you haven't gotten a response yet. Ask if they've had a chance to look at your coverage and if they can use you. If they say they didn't like your coverage, try to find out why. Ask if there was something in particular that they thought was weak in your coverage. You may not agree with their assessment, but you may find the advice helpful, in which case you can use it in preparing a new sample to send in a couple of months later.

If, say, ten to fifteen story editors look at your sample coverage and have objections to how it was written, see if there's a consensus between them about what was wrong with it. You may decide it's worthwhile to write a new sample.

If you get to the end of your "A" and "B" lists without getting a job, go back to the directories. Find companies to replace the ones that either don't use readers or have already seen one of your coverages but turned you

down. Now you will have updated "A" and "B" lists and it's time to start calling again.

Once you've called the new listings, if you still don't have a strong lead on a job, check the dates you called the companies on your original list. Call those that use readers every six to eight weeks to see if they have an opening yet.

You may get lucky and get a job with the first phone call, but it will probably take more effort. If you're ready to quit after a few rejections, then you're not serious about the job. Plus, story editors like to know you're serious about it. Calling several times shows them you are enthusiastic.

Besides, if you quit, you are one hundred percent assured of failure. If you keep trying, you always have a chance of success!

STRIKING PAY DIRT or DIRT CHEAP?
How Much Money You Can Make

Whether you're freelance or on staff, the pay varies from company to company.

The bad news is, small companies with small budgets may use interns, staff assistants, or even people working in the mail room to read material rather than hire professional story analysts. Worse, some people are so hungry for this type of work, they will agree to read for free. If you're capable, however, you deserve to be paid.

The good news is, there are plenty of companies large enough and successful enough to afford professional readers.

Freelancers are paid on a piecework basis. As of this writing, the pay ranges anywhere from around thirty to

fifty-five dollars for a script coverage. You get around ten dollars extra in some cases for a rush job. The standard for books or a miniseries script is sixty-five to seventy-five, though a long and complicated project might bring in ninety to a hundred and twenty.

Companies that pay a higher standard rate often don't give you more for rush jobs or longer projects, while those that pay less for a standard coverage may use a sliding scale.

If a company pays more for rush jobs and your schedule can accomodate them, take them as often as you can. You'll make more money for the same amount of work.

You may find one company can keep you reading as much as you want, but as a freelancer, you can work for more than one company at a time if you so desire.

Non-union staff readers may make up to around thirty thousand dollars a year. These are salaried, full-time positions replete with a company office (which will probably not be lavish).

Union story analysts are a slightly different breed. Although the work is essentially the same, the job-hunting tactics and salaries are not always comparable. As reader Rachel Parker says of the union, "It's virtually a key to life-long employment if you can get in."

IATSE, the International Alliance of Theatrical and Stage Employees, is the union that includes story analysts among its ranks. However, unions are not placement services. The union doesn't get you a job and you can't join the union until you have a job. In that regard, you're still stuck with the rest of the job-hunting pack.

But say you land a gig in the story department of a major film studio which is signatory to the union, such as Universal or Disney. Your employer is supposed to notify the union after you put in thirty working days, at which point the union invites you to join. At the same time, the Alliance of Motion Picture and Television Producers (AMPTP) places you on its roster. Should you then lose your position for some reason beyond your control, such as a company lay-off, you will still be on the AMPTP roster and therefore in the running for any new positions that arise. New, non-union story analysts are not supposed to be hired by signatory companies until everyone available on the producers' roster is employed.

Union story analysts are guaranteed a forty hour work week. Union members also receive medical benefits and a pension. The median income for union members is just under forty thousand dollars (based on fifty-two weeks a year of employment). However, pay varies according to a system of twenty-four different classifications dependent on the reader's cumulative employment record and the specific type of work the producer requires. New employees tend to start at the lower classification levels.

Realistically, you won't get rich being a reader, but if money's your sole motivation, you would be more sensible to go into real estate or robotics. If you love to read and you love the movies, then money isn't all that's important, is it? Furthermore, reading has potential for advancement.

TIME COMMITMENTS

Your first few coverages will probably take a little longer, but once you get the hang of it, your speed will

improve. An average-length script of around a hundred and fifteen pages usually takes no more than an hour to read. Figure on about an hour and a half per hundred pages of a novel or biography. If it takes you much longer than this, take a speed reading course, get another job, or resign yourself to making a pittance for doing something you enjoy.

Once the reading is done, writing and editing a standard length coverage for a script usually takes one to two hours depending on content and complexity.

You will also find that truly outstanding or truly disastrous works tend to take less time. The projects with many pros and cons are the ones that require more thought.

I do know a couple of readers who are able to churn out entire script coverages in an hour apiece, but they are fast readers and their "coverages" in such instances are only required to be a few sentences long.

Some people don't like covering books, which take more time. However, the pay is higher than for scripts. Books often reward you, too, with more depth in character development and more style in the writing. Keep track of how much time you spend on each project. You will probably find you average about the same pay per hour for a book as you do for a script.

Considering the pay and the time involved, you will probably make around ten to fifteen dollars an hour on most coverages. It is true that you can make a comparable amount of money cleaning houses. But it's much harder to get a foot in the door of the entertainment industry if you're a housekeeper.

CHAPTER TEN
KEEPING THE JOB

At last, here is the answer to the question that has tormented men for generations: what do story editors want?

I asked a number of them and, with minor variations, got the same answers over and over again. Story editors look for and keep readers who have:

- good writing skills. This includes but is not limited to the ability to tell a story. Go beyond merely relating the beginning, middle, and end; make it compelling.
- good communication skills, both verbal and written. This means being able to express your thoughts, reactions, and evaluations clearly and fairly. It also means being able to communicate with your boss, to understand what is required of you on the job.

- enthusiasm, meaning a love of movies and a strong desire to do the work.
- a sense of pride in the work. This means you deliver clean, correct copy without spelling and grammatical errors, and you deliver it on time.
- time. How many other commitments do you have? If you only want to cover a few scripts a week, your boss will probably be curious as to how you are making a living. Do you have three other jobs, meaning you are going to be late or sloppy with the coverages because you don't have time to do them properly?
- a youthful point of view coupled with maturity. This isn't necessarily a paradox. You can be open to new ideas without being naively enthusiastic about everything, and you can be experienced without being jaded. Strike a balance between eagerness and cynicism.
- a strong visual sense
- a sense of the marketplace. What's popular? What are the top grossing movies and the top renting videos? What are the critics saying? What's popular in spite of what the critics are saying? What audience likes what kind of films?

> "What are the four most valuable things readers should know? Their names . . . and three other important people in the industry." - Anonymous Wag

THE READER'S ROLE

The real status of readers is peculiar. Outsiders don't know they exist. Insiders often wish they didn't have to exist. After all, who wants to submit a project to a company and discover the Head Honcho passed it on to a reader? Yet Head Honchos don't have time to read everything themselves and it is unrealistic to expect them to do so. In fact, readers not only save executives time, they speed up the whole submission process. Without readers, the backlog of unread scripts and books would be impenetrable.

Besides, if readers are well-trained and capable, why shouldn't companies employ them?

Yet story analysts themselves often have hazy notions about what their coverages are used for and what function their jobs are intended to fulfill.

As a reader, your primary task, as mentioned above, is to save executives time, *not* to rewrite a project. Simply read and then communicate what you've read. The ultimate responsibility for evaluating a work lies with the higher-ups. Occasionally your comments may be passed on in some form to the writer or someone in development, but detailed suggestions from a reader about how to change a script will usually go unused.

Readers are also weeders: they weed out the undesirable. Your coverages help executives decide which projects warrant more or less of their attention. You could be the one to ensure an A-list actress doesn't waste time reading a B-grade script. You could be the first to champion a new writer.

Your positive or negative evaluation will carry more weight if:

- an unknown writer seeking representation has submitted the project
- it's a B-grade movie with a low budget
- the project is still in the very beginning stages of development

Your evaluation will carry less weight if you're covering a "go" project slated for production. The project will not be dropped just because you, the reader, object to it. On the other hand, if you like it, fine; but it's already a "go."

HOW COVERAGES ARE USED

Your coverage may be used in meetings as a springboard for discussion. In large companies, executives need to know what their colleagues are working on. Coverages help everyone in the company stay informed.

Your coverage may be used as a reference point for casting.

Sometimes a coverage will be sent to a composer to give them the drift of a work so they can start creating the music.

Perhaps copywriters in a marketing department need to know the essentials of a story so they can start thinking about sales copy.

Often your coverage performs a "checking" function. Many executives use coverages this way: they read scripts themselves, but they want to hear other opinions. For example, I once covered a script slated for an up-and-coming actress. I passed on it, then found out I was one of

a number of people, including story analysts and executives, who had read the same script and disliked it. In this case, I served as something of a safety net, to corroborate other people's reactions.

Executives rarely rely solely on readers' reports in making important decisions. On the other hand, they tend to be secretive about the projects they haven't read. They may quote part of a coverage over the phone to a client, for example, making it sound as though they have read the work themselves. Again, not to defend or pass judgement on the practice; it's another one of those facts of entertainment industry life. In such instances, an objective, well-written coverage will serve to get the necessary information across concisely, and will show your employer in a good light, which bodes well for you.

TURNAROUND TIME: THE DEADLINE

The deadline is part of the job. If you can't meet the deadline, you won't keep the job. It's that simple.

Some companies allow only twenty-four hours for a script coverage. Some hand you a script and want the coverage back the same day. The latter is more often the case among full-time staff readers who work on the company premises rather than at home. Other companies may give you two days: if you get a script on a Monday, your boss will want it back on a Wednesday. You generally get an extra day or two for book coverages.

Because the deadline is so short, there isn't much chance of getting a job as a reader for film or television unless you live in Los Angeles, New York, or another major production center. Of course, it's conceivable you

could send scripts and coverages back and forth via facsimile, but by the time you can afford a FAX machine in your home, you probably will have been promoted.

CONFIDENTIALITY

Some companies require that you sign a form stating that you will keep what you've read confidential. In other companies, it's merely an unspoken rule. Your job as a reader is *not* to talk about what you've read all over town.

What this means is, while working for one company, you neither call another company with hot tips on the latest scripts you've read, nor do you offer them a copy. First, the work is copyrighted and it is illegal for you to make copies. Second, if the script happens to be fantastic, your employer will resent it if you leak the information to a rival company and start a bidding war. Third, determined writers, producers, and agents submit projects all over town themselves, so it's hardly up to you to do it for them. Fourth, some companies swap or share coverages with other companies for a variety of reasons, such as when they have co-production deals; so again, it isn't up to you to do it.

Another reason for confidentiality is that many people don't like to think their submissions have been given to a reader and they will be offended if they find out.

Furthermore, if you dislike a work and loudly tell your pals or co-workers, your scathing verbal critique could be overheard by the wrong people. Such lack of discretion reflects poorly on your employer and could mean the end of the job for you.

Yes, you can talk about your work, but word does get around, so let it be a diplomatic word.

CHAPTER ELEVEN
WHERE READING CAN LEAD

> Old readers never die, they just go into
> development. - Ancient proverb

Reading professionally is an avenue into two main areas of
the entertainment industry: the executive branch and the
screenwriting branch.

One of the classic readers' success stories is that of
Sherry Lansing. She worked her way up through the ranks
from story analyst to president of Twentieth Century Fox
Studios. She later formed Jaffe-Lansing Productions with
Stanley R. Jaffe. Her background training for story analy-
sis? A Bachelor of Science degree in Speech with a major
in English, and experience as an actress and model.

THE FAST TRACK

An executive position is the most likely goal to be realized directly through a reading job. After you've been reading for awhile, you may want to put together a portfolio of your best coverages and begin actively looking for jobs higher up in development.

A capable reader might first move up to *story editor*. The pay ranges from around twenty-five to fifty thousand a year. Story editors have staff positions and often function as staff readers in a way. In fact, at small companies, the story editor may essentially be a reader. In larger companies, story editors (the heads of the story departments) are the ones who farm out the work to various readers based on their knowledge of their readers' strengths and weaknesses. They then screen the works the readers think are good or those that look interesting in spite of a reader's negative evaluation. Some projects require several coverages. In that case, the story editor may do one as well. If a project needs immediate coverage, the story editor may be the one who does it.

Most scripts are rewritten numerous times. Story editors often work with writers, agents, producers, or directors on a particular script, honing the story. Story editors may be involved in development meetings, often up to the point of shooting. In a production company, they may work on in-house concepts. They may also be responsible for writing rejection letters.

The next step up from story editor is *Director of Development*, sometimes called Head of Development, Creative Director, Director of Creative Affairs, or one of many creative variations on this theme. This is a middle level

management position. The job requires meeting with agents, producers, directors, and writers, looking for good scripts and books, perhaps overseeing a project from conception to the final draft of the script.

From Director of Development, promotion may go in a number of directions, depending on your goals. You may be offered a vice presidency, for example.

Some say you have a better chance at promotion if you're a staff reader because you're at the company interacting with people all day, every day. This gives them a chance to get to know you. However, others say you have just as good a chance for promotion as a skilled freelance reader. As long as you're doing an excellent job, your work will be noticed on some level.

If you have your eye on an executive position, it's important to be outgoing. Shy, retiring types are not usually suited for the wheeling and dealing, phone calling, and meetings required of an executive.

THE NON-EXECUTIVE or NOT-SO-FAST TRACK

If your goal is to be writing, producing, or acting for a living, you may not be "discovered" as a creative artist through your reading job. However, it can be excellent training.

Reading as many scripts as you can get your hands on is likely to give you an innate feel for the medium. You'll get a sense of the rhythm of professional scripts. You'll learn to discern what does and does not work in a script. This can have a positive influence on your own creativity.

In addition, story analysis exposes you to a broad spectrum of work. Even well-educated people tend to screen

out material. They go to the kinds of movies they like, read the kinds of books they like, and ignore the rest. Exposure through professional reading to many different types of stories and styles of writing, even those you don't like, is eye-opening.

You'll also learn what the competition is like. What kind of work will stand out in the crowd? Which ideas have been done to death?

You will also have an opportunity to find out what's happening behind the scenes in the industry. You'll see which projects are in development, which are "go" projects, which ones never have a chance to be made into films, and why. You'll be able to apply this knowledge to your own work, especially if you're a writer or producer.

Furthermore, it never hurts to meet people in the business who might someday consider taking a closer look at what you're doing on your own.

Also, though this may not seem like a positive side-effect at first, working as a reader can help you build up your tolerance to and understanding of rejection. All creative artists face rejection, usually lots of it. As a story analyst, however, you'll be forced to do some serious rejecting of your own. You'll start to see the other side of the coin: the mountains of submissions, the quality of those submissions, and the pressure of deadlines that readers face. This will give you fortitude as you submit your own work.

But above all, freelancing as a story analyst offers the enticement of the freedom and time to pursue your other goals.

One drawback to being a story analyst and a writer simultaneously is that story analysis uses up creative energy and writing time. Some writers find it difficult to switch gears from writing coverages to writing their own material.

To overcome this, schedule time to work on your personal projects during your most productive, energetic part of the day. Some people are "morning people," while others may get a burst of stamina late at night. Give your own work top priority, then do your coverages later.

THE PROMOTION TIME LINE

Of the former readers interviewed for this book, those who became executives were promoted or found a higher position in another company within anywhere from six months to six years of starting their reading jobs. Most were promoted in less than two years.

Those who are now accredited writers did service as story analysts for six months to a year. They got the experience they wanted and then moved on to other things.

CHAPTER TWELVE
THE FREELANCER
AND THE IRS

Freelance reading can be defined as a small business and as such, similar tax laws apply. If you work out of your home, you qualify to take some expense deductions for your story analysis business.

If you have an unrelated office job but you moonlight as a freelance reader at home, you also qualify.

On the other hand, if you are a staff story analyst with a company office but you sometimes take work home, you *don't* qualify.

Since state and federal tax laws and forms are subject to change, this chapter is intended to serve only as an overview of the necessary records you will need to keep in order to claim your deductions. Consult with an accountant or call the Internal Revenue Service information number listed in your phone book to find out which tax forms you will need and what percentage of expenses you can

deduct for your small business. Also ask about forms you must fill out for self-employment.

TAXES AND SOCIAL SECURITY

If you're freelance, there will be no taxes or social security withheld from your paycheck. However, you will still be expected to pay them. Be prepared to report your freelance income and, if necessary, to pay federal and state taxes and social security on what you earn as a reader.

KEEPING THE BOOKS

You do not have to make a profit to take deductions. This is especially good news if you have another job and you are using freelance story analysis to supplement your income. The deductions you can take for your freelance work may help lower your taxes overall.

Good records are important, however. You must be able to back up your deductions with the proper book-keeping. Luckily, it's fairly easy to keep track of your expenses and income.

Expenses. Save your receipts for all deductible expenses. Money spent on paper, pens, typewriter or printer ribbons, paper clips, staples, and other miscellaneous office supplies are tax deductible. You can deduct the price of your computer, typewriter, and other business equipment. Books (including this one), even the price of movie tickets and video rentals (you have to stay up on what's happening in the entertainment industry, after all) are tax deductible. So are subscriptions to or single copies of magazines pertaining to the industry, such as *VARIETY* or *THE HOLLYWOOD REPORTER.*

You can also deduct dues to entertainment-related organizations. Fees for classes and seminars related to your reading job are deductible.

Deductions for certain transportation expenses are admissible as well. Keep track of mileage to and from the offices where you pick up and drop off your reading work. Keep track of mileage when you go to the movies or attend industry-related classes. Keep receipts for parking expenses. You may be able to deduct a portion of your auto insurance also.

If you're renting your living quarters, you may be able to deduct part of your rent as a business expense. Ditto for utility bills and renter's insurance. The deductible percentage is based on the ratio of how much space you use exclusively for your work compared to the total square footage of your apartment. Consult an accountant for a more precise evaluation of how much you can deduct considering your individual situation.

Again, be sure to save your receipts. When you get them, make a quick note on them as to what you purchased (office supplies, business equipment, dues and publications, car expenses, and so on as listed above.)

You will also want to keep a journal or ledger of the amounts you spend in each category. The best way to handle this is to mark down expenses as you go. Otherwise, you have to go through all your receipts at the end of the year and total everything then.

I use an appointment book that includes for each month an envelope in which to store each day's expense receipts. On the outside of the envelope are columns for the various types of expenses: supplies, dues and publica-

tions, rent, utilities, and so on. I record my expenses as I incur them, then slip the receipt in the envelope. This saves having to post amounts to a ledger every month or two, or at the end of the year.

If you don't want to purchase a similar appointment book, you can easily design your own expense folder using a simple manila envelope. Label the columns, mark down your expenses in the appropriate columns, and slip the receipts in the envelope. Space considerations and ease of organization make the use of a separate envelope for each month advisable.

Income. Keep track of your income, including any income from sources other than your reading job. Keep paycheck stubs and invoices. (I store mine in my expense envelope as well.)

Again, check with an accountant or the IRS for the specifics on what deductions you can legally take.

CHAPTER THIRTEEN
SAMPLE COVERAGES

The coverages in this chapter were written by professional story editors and story analysts. Use these coverages as guidelines. Compare the various styles of writing and company formats. Over time, you will develop your own style of writing. And of course, the format your employer prefers may differ slightly from the ones in this chapter.

We begin with the spec coverage I did which got me my first job as a reader. In fact, it's the first coverage I ever wrote. Looking at it now, it seems terribly long winded, but it did the trick, so who's complaining? Due to the format of this book, the synopsis and comments appear longer than the originals. Those came to two and one-half pages for the synopsis and about two-thirds of a page for the comments, standard lengths in the samples I was given by my future boss.

Read my coverage and consider how you would revise it to make it better. Consider also what selling points it has, why it was good enough to get me the job despite its faults. My ideas on how it could be improved are offered following the coverage.

By the way, you may notice a change in the writer's credits on the final film version. Scripts often go through numerous rewrites. Advance publicity for this film credits Chuck Pfarrer for the screenplay.

```
TITLE:  Navy Seal
WRITTEN BY: Angelo Pizzo
FORM/DRAFT/PAGES:  Screenplay/10-12-88 draft/
                   100 pages
GENRE:  Action/Drama
TIME/LOCALE:  Present/Middle East, Navy Base,
              Washington
SUBMITTED FOR: ---
SUBMITTED BY: ---
ELEMENTS: ---
COVERAGE REQUESTED BY:  ---
READER:  T. L. Katahn
DATE:  ---
```

THEME: A secret Navy combat unit is given
seemingly impossible missions in the war-torn
Middle East.

A Kuwaiti supertanker strikes a mine in the Persian Gulf. A U.S. chopper goes to aid the injured and is shot down by an Islamic Revolutionary gunboat.

Back in the States, LT. JAMES J. CURRAN and his buddy LT. DALE HAWKINS flirt with a woman in a bar and get into a fight with her boy-friend. Curran receives a phone call and he and Hawkins leave the bar suddenly.

Meanwhile, the chopper pilot and medic are being interrogated and viciously beaten by the Islamic terrorists, the worst of the punishment coming from a mysterious ARAB in civilian clothes who then leaves the room. The medic is unconscious and bleeding. The door explodes open and a group of gunmen level the terrorists. The gunmen are re-vealed to be the Navy Seals secret commando team of Curran, Hawkins, RAMOS, LEARY, GRAHAM, and DANE. The medic and the pilot are whisked out of the room.

Curran, Hawkins, and Ramos find the mysteri-ous Arab who convinces them that he is also a prisoner of the terrorists. The Seals let him go. The Seals find a stack of crates containing missiles made in the U.S. As the leader, Curran must choose between getting the medic to a hospital quickly enough to save his life or taking the time to blow up those missiles. He chooses to save the medic's life.

Curran and Hawkins spend Easter Sunday at Curran's parents' house in Baltimore. The

men in Curran's family are all cops and we
see where Curran got both his killer and do-
gooder instincts.

The next day Curran meets with a room full of
Naval officers and civilians to discuss
destroying the missiles, which the terrorists
have moved to an unknown location. Among the
State Department experts is AMANDA POE, who
grew up in Lebanon. She is to brief Curran's
team on the situation there. She and Curran
leave the Pentagon together and we find that
the two were once lovers in Beirut. Curran
wants to rekindle the flame, but Amanda will
have none of it.

Hawkins sees Amanda working out in the Naval
base recreation center. He tries to pick her
up but she isn't interested and stalks away.
He finds her shooting basketball alone in the
gym and he suggests a game of one-on-one.
She dazzles him with sleight of hand and
foot, wins the informal game in seconds, and
leaves.

It seems she can't shake Hawkins, though:
they run into each other again in the
Officers' Club where Amanda goes for dinner.
After some witty banter, they find out the
kitchen is closed. Hawkins sways her with
mention of fresh steamed crabs at Carol's
Crab House. They end up laughing and talking
over dinner, and after some more smart dia-
logue and a car chase scene where Hawkins
outruns the police to avoid paying his park-
ing tickets, Amanda and Hawkins end up in bed
together.

The next day Curran informs Hawkins that his
ex-girlfriend is on the base and that she's
off-limits to Hawkins. Hawkins says nothing
about the night before.

Amanda briefs the commandoes. She says the
mysterious Arab the Seals let go is really
ABU SHAHEED, the most extreme of the extrem-
ists.

Hawkins confronts Amanda about Curran, who
overhears them and finds out they spent the
night together. Stunned, he walks away.
Later he harasses Hawkins at shooting prac-
tice. That night Hawkins goes to see Amanda,
but she turns him away. She then tries to
explain her liaison with Hawkins to Curran
but he insists he doesn't want to know.

Amanda briefs the commandoes about the Arab's
moneyman, who probably knows where the mis-
siles are. She says the only way to make a
religious fanatic talk is not to capture him,
but to capture a member of his family.
Though this borders on a violation of inter-
national law, she and Curran convince the
heavies in Washington that such a kidnapping
is possible and necessary. On their way back
to the Washington airport, their cab hits a
young boy on a bicycle. Amanda watches as
Curran tenderly cares for the boy and orders
the cabbie to rush them to a hospital.

The Seals begin intensive training to capture
the terrorist SHEIK HAMANI, brother-in-law of
the Arab moneyman. In the midst of a train-
ing exercise, Hawkins springs a surprise

birthday party for Curran, who reacts with
anger and calls it irresponsible. The rest
of the team is disappointed. Hawkins is
pissed.

The team flies to Sidon outside Beirut to
kidnap Hamani. They kill a few guards and
sneak into the house. Curran, Hawkins, and
Leary surprise Hamani in his bedroom watching
an old, dubbed episode of ''The Brady
Bunch.'' Curran orders Hawkins down to the
front exit, where a servant boy tells them
there are a couple of guards the team didn't
know about. The boy runs out of the house,
Graham follows, Hawkins runs back upstairs to
inform Curran, and Graham is killed. After
much combat, the team manages to get out with
Hamani and Graham's dead body.

The Seals hold their version of a wake for
Graham. Curran isn't there yet. Hawkins
gets so drunk that Amanda offers to help him
home. Just then Curran walks in and makes
all the obvious wrong conclusions. Amanda
and Hawkins leave. Amanda reveals to Hawkins
that she's still in love with Curran.
Hawkins goes to tell Curran, but before he
can, Curran gives Hawkins hell for leaving
his post at Hamani's house. Curran suggests
he transfer out of the Seals. They get into
a bloody brawl only to be interrupted by
Ramos, who tells Curran his superior officer
wants to see him.

Next, Curran briefs the team: the missiles
are located smack-dab in the middle of the
worst section of South Beirut, an area that

is being fought over by scores of radical
factions. It's so dangerous that Curran asks
for volunteers. Naturally, the whole team
volunteers. Amanda sees the men off, letting
Curran know that when (and if) he returns,
they might have some things to talk about.

The men land on a beach in enemy territory,
make their way into and through the hell that
is Beirut, and manage to blow up the mis-
siles. Several of the Seals are killed,
leaving only Leary, Hawkins, and Curran.
Curran is severely wounded, but Hawkins
refuses to leave him behind. They are being
chased by the evil Abu Shaheed, who finally
catches up with them on the ocean. In an
underwater struggle, Shaheed knifes Hawkins
in the stomach, but Hawkins kills Shaheed.
Curran and Leary wait for Hawkins to surface.

Amanda consoles Curran at the funeral of his
best friend, Hawkins.

MAJOR CHARACTERS

LT. JAMES J. CURRAN. 30's? The nerveless, quietly authoritative leader of the Navy Seals commando team, he is in top physical condition. Extreme toughness matched only by his very real concern for human life. In love with Amanda who sleeps with his best friend, Hawkins. (4)

LT.(jg) DALE HAWKINS. 30's? Loose-limbed but sharp-edged, lighter-hearted than his friend Curran, he's a wild one. Sleeps with Amanda but isn't too upset when she goes back to Curran. Saves Curran's life at the end of the film. (4)

ABU SHAHEED, ''Son of the Martyr.'' 37 years old, pock-marked skin, always scowling, ugly. An Arab terrorist, he dresses in civilian clothes. He was educated in Western-style schools, lived in New York, hates everything American. He is easily enraged, sly, and seemingly unstoppable. (8)

AMANDA POE. 30ish, part Lebanese and darkly attractive, tough, intelligent, sensitive. She's an expert in the State Department and the love interest of both Curran and Hawkins, which strains the friendship between the men. She still has a thing for Curran although she hides it from herself. In the end, she goes back to Curran. (25)

For those who like generic violence in their
films, this one should have enough to sat-
isfy. With plenty of combat, plenty of
preparation for combat (perhaps overmuch; the
pace is a little slow here), but nothing too
grisly or graphic, this otherwise fairly
straightforward story about commandoes has a
surprisingly strong, savvy female lead,
Amanda. The other characters are not unusu-
ally interesting, but they're likeable
enough: Curran has a tender streak, while
Hawkins has a dare-devilish charm.

Overall, the dialogue is believable and
bright. The only unbelievable moment comes
when Amanda makes a stab at explaining the
whys and wherefores of the complicated situ-
ation in the Middle East. An attempt to
evoke sympathy for terrorists, Islamic or
otherwise, is beyond the scope of this
script. Amanda briefly touts Islam as a
''tolerant'' religion, which simply won't be
swallowed whole by anyone who knows much
about world religions. Amanda's part Leba-
nese, but is she Muslim? If not, why does
she sympathize with them? If she sympathizes
with them, why is she helping the Americans?
I kept expecting to discover she had family
ties with the terrorists, but it never hap-
pened. (Why isn't Abu Shaheed her brother,
for example?)

The script never addresses the underlying
implications of Arab possession of weapons
made in California, but then, that's probably
not the writer's intention. The messages are
basic: war is futile yet inescapable, so

you'd better be able to outfight the other
guy, and by the way, don't sleep with your
best friend's girl. Or if you do, don't get
caught.

This movie is for the macho men among us.
There is a good deal of ''male-bonding-
through-violence.'' All in all, this is not
a momentously profound or original script,
but it isn't dull either, and there are
enough subplots to keep the story moving.

	EXCELLENT	GOOD	FAIR	POOR
Characterization		x		
Dialogue		x		
Story Line			x	
Setting/Production			x	
Structure			x-----------x	

Budget: low____ medium_x_ high____

Consider_x_ pass____ recommend____

REMARKS
Weaknesses and Strengths

The Synopsis. I included far too many beats in the synopsis. If I were writing it today, I would probably be able to cut the length in half. For example, I would leave out mention of the first scene in the bar, the scene with the boy on the bicycle, and the birthday party. I would leave out the step-by-step details of Hawkins and Amanda's involvement, and of the ways Curran expresses his jealousy. I might merely make a general statement such as, "The unspoken rivalry between the two men escalates as the Seals train for combat." I would leave out the minor details about the mission to Hamani's house, although the fact that Hamani is watching a dubbed **Brady Bunch** rerun does give a feel for the humor in the script.

Remember, the outcomes of major scenes lead to the next major scenes; these are the important beats to include in your synopses.

Good aspects of the synopsis include the use of words like "explodes," "whisked," "stalks," and "dazzles," which add excitement and visual appeal. There are also glimpses of what the characters are feeling, which help define the tone of the piece.

The Character Breakdown. Though the opening descriptions of the characters are lifted directly from the script, I added too much information relating to the plot. This is redundant, since it's already in the synopsis.

I also listed the characters in the order in which they appeared instead of in order of importance. I didn't yet know to put the female lead right after the male lead. (If the female had been the main character, she would have

appeared first.) The buddy, Hawkins, would then appear third.

On the plus side, the character breakdown is thorough enough to give clear pictures of the main characters as required. Mission accomplished!

The Comments. Notice the use of "hedging words" such as "perhaps," "a little," and "fairly" in the opening. I would delete these if I were writing the comments today.

I would also delete my brief foray into religion, although with the conflagration over Salman Rushdie, it is certainly relevant to world issues. It would have been more appropriate, however, to stick to a discussion of the inconsistencies or mysteries in Amanda's character development.

I would include that this script has several contrived moments. For instance, the scene with the boy on the bicycle is an obvious plant to show us that Curran is really a swell guy despite his gruff exterior. Hawkins' death is a convenient way to resolve the love triangle. Plus, a standard plot development in films like this is that the hero survives while his best friend dies.

Now for the good points. The comments address most of the main elements, such as concept, plot, characters, and dialogue. Pace was mentioned, and though more could have been said about structure, factors such as believability and probable audience were discussed.

Go see the movie. Did the coverage give you a feel for what the film would be like?

Hindsight is twenty-twenty, of course. We are always improving our skills, and in looking back on our work, we

will almost invariably see ways to make it better. Considering the time limitations placed on readers and the amount of money they make, there is only so much editing and perfecting of coverages that anyone can reasonably expect.

So, when writing your coverages, do the best you can within the time frame available, then turn in the work and forget about it. Go on to the next project.

Next are two coverages of the same screenplay, **Total Recall**. Notice that both readers chose to bring out some different points of the story, but that the main beats were mentioned in both synopses. Notice that the two readers mentioned positive aspects as well as drawbacks in their comments. Notice also that someone else agreed the script had potential *and* was willing to put up the money to have it produced: the film is slated to be released in June 1990, starring Arnold Schwarzenegger.

Watch for the writer credits on the film to see if the final script is the same as the one covered here.

STORY REPORT
Title: TOTAL RECALL
Form: Screenplay (110 pp)
Author: Ronald Shusett & Dan O'Bannon
Genre: Sci-fi
Submitted by: N/A
Submitted to: N/A
Date: N/A
Reader: N/A

CONCEPT: Man undergoes ''memory implant'' only to discover that he is an interplanetary secret agent with amnesia.

STORY: DOUGLAS QUAIL, a meek little man, has an obsession with Mars. Though he can't afford an interplanetary vacation, he finds REKALL, INC., a ''memory implant'' company that can give him a full memory of a wonderful vacation, without having to pay for the trip. However, while undergoing the process, Quail wakes up and realizes that he is an EIO (Earth Intelligence) agent whose memory has been erased by the agency. The technicians try to erase the memories again, but Quail leaves completely disoriented.

Word gets to the EIO of Quail's predicament, and Quail becomes the target for dozens of police and EIO assassins. He eludes them and discovers a secret briefcase left for him. Inside is a bundle of cash, a gun, and a recording: it's his own voice, from the past, telling him to go to Mars if he wants to survive and find out who he really is.

Quail arrives on Mars, which is in the midst of political turmoil: the colonists are getting rebellious. With the help of a black market cabbie BENNIE, Quail tracks down a vaguely familiar name: MELINA. She turns out

to be a truck-stop owner and oxygen bootleg-
ger. Melina is angry when she sees Quail,
and then kisses him passionately. When Quail
reveals that he doesn't remember her and that
he is an ex-EIO agent, she kicks him out.

Back at his hotel, Quail is accosted by
another man -- a DOCTOR -- who claims that
Quail is still on an operating table at
Rekall, Inc. He tells Quail that all of his
experiences -- including the experience of
talking to him -- are hallucinations caused
by the implant going bad. Quail is pondering
whether to believe him when the man is shot
dead by Melina. She explains that the man
was an EIO agent and together they flee from
pursuing EIO assassins. Melina takes Quail
to a psychic MUTANT who hypnotizes him into
recalling all of his memories. Quail comes
out of the process remembering his identity
and his mission.

The EIO, it seems, is keeping the ancient
Martian Sphinx off-limits, because in a
previous mission Quail had discovered that it
was an immense ''Terraforming'' device -- a
fusion-powered machine that could transform
airless Mars into an oxygen-producing, life-
supporting planet. The EIO is suppressing
this to keep the Martian colonies under
Earth's thumb. When Quail realized this, the
EIO tried to destroy his memory.

Quail and Melina head for the Sphinx and
after chases, escapes, and gun battles, they
finally arrive at the central control cham-
ber. Quail's former boss, the corrupt head
of the EIO, tells Quail he'll die if he acti-
vates the machine. Quail ignores him and
starts it up. Huge fusion explosions blast
under the planet, volcanoes erupt, and the
water that is frozen under the planet's core

bursts forth. The hideous planetary cata-
clysm is actually a blessing as Quail and
Melina step out into a rainstorm and breathe
air on Mars for the first time.

COMMENTS: The ideas throughout this script
are fascinating, but the execution leaves a
lot to be desired. Memory implantation,
planetary uprisings, and especially the
paranoid fear of not knowing who you are or
what reality is... these are the real core
and excitement of this piece. (That same
paranoia is also at the heart of MAN OF
STEEL.)

The story is a run of the mill James Bond
epic: secret missions, world domination,
shootings, chases, and a big effects-fest
finale. There is nothing inherently sci-fi
about this; the whole story could be set in
the present. Characters are adequate but not
very interesting. Quail's reaction to his
dilemma is underplayed and much more could be
done with this fascinating problem. Over-
all, this is a huge and expensive project,
with a story that can't really support it.

The concept and many of the elements are
excellent, and a story is in this somewhere.
I think, however, that the great concepts
come from the Philip K. Dick short story....

SUBMISSION: PASS WRITERS: PASS

Notice in the following coverage that the "comment summary" is the log line.

TOTAL RECALL
Screen Story and Screenplay by Dan O'Bannon and Ronald
 Shusett
Based upon a story by Philip K. Dick

Read by Rachel Parker
Time: 2049 Place: California

Comment Summary: DOUGLAS QUAIL, a bored and restless office worker in grim California of the future, decides to take a "fantasy vacation" in the identity of a secret agent only to find out that this fantasy is true.

Synopsis: Downtrodden DOUGLAS QUAIL awakens to another dreary day and mulls over his recurring dream about a vacation on Mars. KIRSTEN QUAIL, Douglas' unsupportive wife, angrily dismisses the possibility of really going on such an expensive vacation.

On the way to work, Douglas hears a commercial by REKALL INC. offering an alternative way to make his dream come true. Rekall sells "a memory of any experience - safer and less costly than the real thing." Quail sheepishly meets with MR. MCLANE, a Rekall rep, and learns that he can receive the memory of a complete two-week vacation in Mars, hypnotically implanted, plus actual ticket stubs and souvenirs. His memory of having purchased this fantasy from Rekall will be erased so he will actually believe he was once on Mars. For an additional fee, he can receive a new identity for the trip. Douglas has always wanted to be a secret agent, so he purchases a memory of his "last mission" - a trip to Mars.

Douglas is anesthetized by Rekall's DR. LULL, but the procedure takes an unexpected turn. Dr. Lull and McLane

are horrified to hear Douglas tell them in a strange, cold voice, "You've broken my cover." It turns out that Douglas Quail was really a secret agent on Mars at one time and someone (probably EARTH INTELLIGENCE AGENCY) erased his memory and gave him a new identity. When Quail is completely unconscious, McLane and Lull frantically decide to erase Quail's memory of coming to Rekall and hope that no one ever finds out about this. They now understand why Quail was so driven to get to Mars.

A disoriented Quail is sent home in a cab to Kirsten, who has been concerned about his absence. He's fuzzy, but vaguely remembers going to get his memory changed. The more he tells the alarmed Kirsten, the more he remembers. Douglas is soon furious at the shoddy service he's received. He marches over to Rekall and tells a frantic McLane that he'll take him to court. On his way out of Rekall, Douglas is picked up by two agents. From them he learns that he is to be killed by Earth Intelligence, as McLane and Lull just were. When physically threatened by the agents, Quail becomes a skilled fighter, with skills he didn't know he possessed. He kills them both.

He discovers that Kirsten is an agent, his marriage merely a memory implant designed as a ruse to keep an eye on him. He escapes, and is soon helped by a trail of clues his real identity left months before in anticipation of a memory erasure.

A disguised Quail travels to Mars and seeks out the beautiful MELINA KWON who turns out to be his girlfriend and member of the MARTIAN LIBERATION FRONT. Earth Intelligence's pursuit of Quail continues and seems to be centered around the ancient Sphinx of Mars. Melina and friend BENNIE bring Quail to KUATO (FAT MAN) who has the psychic power to unearth the truth of Quail's past. Quail now remembers that Earth Intelligence has built a powerful transmitter in the Sphinx that can provide "new personalities" to the masses of Martians it deems to have "socially

deviant attitudes." Quail and friends attack the transmitter. It is set to self-destruct after their attack and they are racing the clock to destroy it and escape. Quail is able to turn the transmitter's powers against Earth Intelligence's evil VILOS COHAAGEN. Cohaagen is programmed to think he's the meek Douglas Quail. The real Quail and Melina resume their romance under the two Martian moons.

Comment: This screenplay gets off to an intriguing start. The concept of being able to purchase any adventure, any vacation, and any identity simply by having the memory of these things implanted in the mind sets your imagination rolling. Where would you want to have gone? Who would you want to have been? The combination of Quail's forlorn mental state and the dreariness of his futuristic surroundings make his desire for a glamorous escape all the more understandable. When we are so joltingly faced with his true identity while he's under hypnosis, you can practically hear a starting gun go off. A race has definitely begun.

From such a promising start, the plot begins to take some distracting twists. Once we get to Mars, special effects, a focus on the secret of the Sphinx, and a few weird characters slow the pace down. The material here is not quite as clever or original. A klaxon counts down the number of minutes our hero has until the Sphinx self-destructs with him in it. This device plays a bit well-worn here. The final scene with Quail and Melina so wrapped up in an embrace they can't hear a question from Bennie is a classic James Bond ending. The screenplay seems to deserve a little better than that.

Douglas Quail is an interesting and likable character. He provides a little bit for everyone to relate to. He's both Clark Kent and Superman; hen-pecked husband and handsome stud. Quail's character is a good focus for the plot, although the plot could use more focus.

STORY REPORT

Title: HEATHERS Form: Screenplay
Author: Dan Waters Genre: Black comedy
Submitted by: -- Submitted to: ---
Reader: -- Date: ---

CONCEPT

When a girl tries to make her friend's death look like suicide, it touches off a string of teen suicides and media hoopla.

STORY

High school junior VERONICA has given up her old friends to join the coolest clique in the school, led by HEATHER CHANDLER, bitch of bitches, and two other beautiful but submissive girls also named HEATHER. Veronica is appalled at how the clique delights in making other people's lives miserable, but hangs out with them anyway.

Veronica is attracted to a mysterious new guy at the school: J.D., a James Dean lookalike. Veronica goes to a college party with Heather and is humiliated by her friend. She decides that she has to stop Heather from hurting others.

The next morning Veronica and J.D. go to see the hungover Heather and accidentally give her a mixture of kitchen chemicals instead of a hangover cure. Heather drinks it and dies. J.D. suggests that they make the death look like a suicide, and together they forge a suicide note.

In death, Heather becomes a celebrity. The school gives the kids the day off, and TV crews interview students, who claim that Heather's death means a lot to them. Veronica is shocked by the reaction.

J.D. suggests that they use the situation
to play a practical joke. Veronica calls two
obnoxious JOCKS to meet her in the woods.
She tells them both to undress, then J.D.
steps out and shoots them both with ''stun''
bullets. They then plant a forged homosexual
suicide note on the unconscious bodies, with
the hopes that when they wake up people will
already think they attempted a ''fag'' sui-
cide. The joke seems funny until J.D. re-
veals that there's no such thing as ''stun''
bullets. The jocks are dead.

The new suicide story makes national
news. TV crews mob the school and a New Age-
esque teacher tries to lead the students in a
circus-like ''healing process.'' MTV plays a
hot new video about teen suicide, dedicated
to the school. Veronica is nearly catatonic
with guilt and refuses to see J.D. J.D.
blackmails HEATHER DUKE into circulating a
petition about a band playing at the prom.
Heather Duke begins taking on the bitchy
mannerisms of the deceased Heather. She
becomes immensely popular, getting signatures
from every kid. Veronica tries to stop
Heather, much to J.D.'s annoyance. Veronica
realizes that J.D. may try to kill her and
make it look like suicide. J.D. arrives at
Veronica's house to find that she's hanged
herself. He explains to the corpse that he
has changed the petition so that it is a
suicide note signed by the entire school. He
intends to blow up the school and everyone in
it. After J.D. leaves, Veronica lets herself
down from the noose harness.

Veronica goes to the school, tracks down
J.D.'s bomb, and fights J.D. in order to
defuse it. In the fray, she kills J.D. with
his own gun. She defuses the bomb, then

watches the passing students in the cliques, their insensitivity, and their self-centered- ness. Veronica starts the five-minute timer on the bomb, straps it to herself, then walks out of the school.

COMMENTS: Fascinating black comedy treads the line between EATING RAOUL and THE BREAKFAST CLUB; a combination of John Hughes and John Waters.

The characters throughout are so hip that they're unbelievable. This works when we know it's a comedy, but when we think it's a sensitive teen drama (as we do in the first act) it's a little forced. The transitions from normalcy to outrageous black comedy are subtle and gradual. I often found myself in the middle of sheer lunacy without realizing how I got there. This dynamic makes the comedy very funny, and the story easily crosses and re-crosses the line between humor and horror.

The story loses steam in the second act, and only comes back to full speed with the group suicide threat. It's never quite clear why Veronica is so desperate to be popular at the beginning, nor is it clear why she con- tinues to kill her buddies. Though many of the characters need a little more focus, they are all basically strong.

The line between comedy and tragedy is hard to walk. This script does it well, with big laughs and big insights, in the tradition of films like DR. STRANGELOVE. The real problem is that there may not be a big market for a slapstick look at teen suicide.

SUBMISSION: Pass
WRITER: Qualified Recommendation

As you probably know, **Heathers** was eventually produced and enjoyed a reasonable amount of critical acclaim and success at the box office, despite (or because of) its bizarre subject matter. If you've seen the film, you also know it has a more upbeat ending than the one presented in this version of the screenplay.

STORY REPORT

TITLE: The Broken Cord AUTHOR: Michael Dorris
FORM: Book/Autobiograpy GENRE: Drama
TIME: 1971 to present PLACE: Alaska, New
 England, South Dakota
SUBMITTED FOR: --- SUBMITTED BY: ---
ELEMENTS: --- READER: ---

LOG LINE: A young man adopts a three-year-old boy and spends years denying the child is retarded. At last the boy's violent seizures and lack of development force the father to come to grips with and research his son's illness.

SYNOPSIS:
MICHAEL DORRIS decides to adopt a Native American child who has been diagnosed as mentally retarded. Michael believes the boy, ADAM, has been misdiagnosed, and has simply had a difficult time in his first three years of life.

A DOCTOR assures Michael that Adam's slow development is due to his premature birth. But while driving home one snowy night from a job interview in another city, Michael gets lost. With Adam asleep in the back seat, Michael chooses to keep driving without waking Adam to feed him. At last they arrive home safely. But in the morning, Michael finds Adam unconscious and feverish on the floor. Michael hurries him to the hospital where the DOCTOR only guesses at what's wrong. Michael researches the symptoms in the library, but finds no real answers. On the advice of a resident friend, PETER BLASCO, Michael decides to move Adam to a major medical center. The local Doctor is, of all things, offended.

Michael follows the ambulance carrying Adam to the hospital at breakneck speed. There, a mystified DR. STORRS prescribes Dilantin for the seizures. Adam will take it for the rest of his life.

Several weeks later when Michael and Adam are stranded at home during a blizzard, Adam has a terrible night of high fevers and twelve seizures. Later, an EEG shows a lesion in Adam's brain which could mean he has encephalitis. Plus, the boy is suffering side effects from the drugs. He can't learn to count or distinguish different

colors. Yet Michael continues to make excuses for the boy's lack of progress, blaming racism and culture-biased IQ tests for Adam's low scores.

Michael remembers hearing case workers discuss Adam's parentage: his mother died from drinking at age thirty-three. His grandmother went on frequent drinking binges. His father was an alcoholic and petty thief who was beaten to death in an alley. As Michael becomes more and more involved in teaching Native American studies at Dartmouth, he also begins researching the effects of alcohol on the Native American population.

Michael adopts another boy named SAVA and a girl named MADELINE. He meets writer LOUISE ERDRICH at a powwow. After a lengthy long-distance "courtship" during which Michael does a research fellowship in New Zealand, Michael and Louise marry.

Adam graduates from elementary school, having been promoted through the grades because he's loveable, not because he's been able to learn what was required. Expensive sessions with a psychologist prove useless. Vocational training doesn't seem to hold much promise for Adam, who has trouble remembering things.

On a trip to a reservation rehabilitation center for teenagers, Michael sees for the first time several Native American adolescents with the same physical characteristics and behavior as Adam. The DIRECTOR of the center explains that they have FAS, Fetal Alcohol Syndrome.

Michael begins extensive research into FAS in a desperate attempt to understand his son's condition and what, if anything, can be done about it. His research shows him how widespread and serious a problem FAS is, especially on reservations where cultural pressures encourage people to drink. Michael hopes to alert people to this preventable disease, caused in fetuses when mothers drink alcohol during pregnancy.

COMMENTS:

This is the kind of heart-breaking true story that deserves to be presented to the world.

The characters are real, involving, and three-dimensional, replete with flaws and foibles as well as good qualities. MICHAEL's amazing persistence in denying Adam's condi-

tion is a very human trait with which the audience will identify easily.

Moments of lightness and humor relieve the overall painfulness of the story. As for setting, the insider's exploration of Native American culture is engrossing.

About halfway through, however, this book becomes more of a scientific study than an autobiography. The many conversations and conferences Michael has with experts in the field of FAS research would be difficult to translate to film without the dialogue being too talky and technical, and the action slowing to a crawl.

Despite this, there is definitely enough of a visual plot here, chronicling Adam's growth and lack of development, struggles and small triumphs, to make a moving film especially suitable for television.

This is the type of story that loses a great deal in the synopsizing; it's worth looking at the book itself. The human touch is very strong here.

	EXCELLENT	GOOD	FAIR	POOR
Characterization	x			
Dialogue		x		
Story Line		x		
Setting/Production		x		
Structure		x		

Budget: low__x__ medium____ high____

RECOMMEND

APPENDICES

SUMMARY OUTLINE
HOW TO WRITE COVERAGE

You will find this summary especially useful as a quick reference guide when writing your coverages. The main points of each coverage component are outlined here to jog your memory.

I. The art of reading
 A. Look for:
 1. The main points of the plot
 2. The main and supporting characters
 3. Aspects of the work pertaining to the purpose of your coverage
 4. Visual value
 B. Ignore:
 1. The little things: typos, grammatical errors, tense changes, and the like

 C. Skim:
 1. Fight scenes
 2. Chase scenes
 3. Love scenes
 4. Bloodbaths
 5. Background and internal action unrelated to the main plot or to major points of character development

II. Writing the synopsis
 A. Stick to the main plot
 B. Write as much as you can from memory
 C. Capture some of the mood or tone of the work
 D. Use evocative words (use a thesaurus)
 E. Simplify
 F. Show the work in its best light

III. Writing the character breakdown
 A. List roles in the following order:
 1. Leads
 2. Co-stars
 3. Supporting roles
 4. Minor roles
 5. Cameos
 B. For each character, include:
 1. Name
 2. Age
 3. Physical appearance
 4. Personality or background
 5. Page number on which the character first appears
 C. Follow closely the writer's description of the character

IV. Address comments to:
- A. Concept
 1. How original it is
 2. Whether it's high concept or a soft story
- B. Premise/theme
 1. Strength
 2. Universality
- C. Plot
 1. Predictability
 2. Obstacles, complications, reversals, twists
 3. Believability
 4. Subplots, if any
 5. The hook, if any
 6. Continuity
- D. Main and supporting characters
 1. Background
 2. Range of emotion and expression
 3. Motivation
 4. Fatal and other flaws
 5. Evolution
 6. Consistent development
 7. Rooting interest
 8. The spice of life: variety of characters
 9. The proof of the premise: the right hero for the story
 10. In general, what kind of talent would be appropriate
- E. Dialogue
 1. Reveals character traits
 2. Reveals essential information
 3. Flows or flounders

4. Is over- or underwritten
5. Sounds like people talking
 a. Is appropriate for the various characters
 b. Is appropriate for the time period and culture
F. The stakes
 1. What is at stake?
 2. How crucial is it?
 3. How dangerous is it?
G. Structure
 1. Use of back story or ghost (a beginning that is really the middle)
 2. Proper setup of main character and conflict in the beginning
 3. A middle that smoothly follows character development and pursuit of the goal
 4. An ending that resolves the conflict presented in the beginning
H. Pace
 1. Fast, slow, or varied
 2. Appropriate for the tone and theme of the piece
I. The writing itself
 1. Mastery of the craft
 2. Individual style
 3. Concept and execution
J. Audience
 1. Age
 2. Sex
 3. Media
 a. Feature film
 b. Public television production

 c. MOW (TV movie of the week)

 d. TV series, drama or sitcom

 e. Miniseries

 K. Does the work succeed in its objectives?

 1. Realization of the premise

 2. Evokes the intended emotional response

 L. Comparisons

 1. Refer to genre

 2. Refer to similar films if appropriate

 M. Overall reaction

 1. Mention anything unique about the work

 2. Is it a good blueprint for a movie?

 N. The grid may include any or all of the following:

 1. Characterization

 2. Dialogue

 3. Story line/plot

 4. Setting/production value

 5. Structure

 6. Theme/concept

 7. Writing ability

 8. Budget

 9. Recommend, consider, pass

V. The cover sheet

 A. Copy info directly from the work itself when possible

 B. Use "N/A" when information is not available

 C. Write a catchy, brief log line

VI. Editing

 A. Organize your thoughts

 B. Be clear and concise

 1. Cut out unnecessary phrases

2. Beware of redundancies
3. Use verbs instead of nouns to express action
4. Use verbs in the active voice instead of the passive
5. Keep subject, verb, and object close to each other
6. Express one thought per sentence or clause
C. Refer back to the project itself as necessary for accuracy
D. Check spelling, punctuation, and grammar
E. Use running heads
F. Keep a copy of each of your coverages

APPENDIX B
STANDARD FORMATS
FOR SCRIPTS AND MANUSCRIPTS

If you are interested in writing scripts, there are comprehensive guides to correct format, such as *THE COMPLETE GUIDE TO STANDARD SCRIPT FORMATS* by Cole and Haag.

As a reader, you simply need to know the basics.

Scene headings tell you where and when the scene occurs. They are written in ALL CAPS.

Stage directions describe the setting and the activity taking place. Characters are introduced in the stage directions as well.

Character cues are characters' names centered in the page, written in ALL CAPS. They indicate which character is supposed to speak.

Personal directions are brief notes to the individual character (actor) and appear in parentheses just under the character cue.

Dialogue is what the characters say.

The basic layout for a screenplay is as follows:

```
SCENE HEADING - WHERE - WHEN

Stage directions describe the setting a bit
more and introduce CHARACTERS.  Actions are
described here as well.

                    CHARACTER NAME
                     (direction)
            dialogue dialogue dialogue
            dialogue dialogue dialogue

                  ANOTHER CHARACTER
                  talk talk talk
                  talk talk talk

                                    CUT TO:

ANOTHER SCENE HEADING - ANOTHER PLACE - TIME

More stage directions.
```

And so on.

Some aspects of teleplay format vary from that of the screenplay. For example, dialogue is double-spaced in a television script. But the fundamentals remain the same.

Book manuscripts usually are double-spaced, in paragraph form (indented paragraphs). They include running heads with author name, page numbers, and often an abbreviated form of the book title.

Publishers prefer to receive book manuscripts loose-leaf (unbound). However, working in the film and television industry, you will often receive them in covers with brads or fasteners, like a script.

APPENDIX C
GLOSSARY
OF
SCREENPLAY TERMS

Terms are used in ALL CAPS except where otherwise indicated. Punctuation is used as shown.

AD LIB Actors make up dialogue appropriate to the scene.

AERIAL SHOT A camera cue. As if from an airplane.

b.g. Background.

beat Means "pause." Usually used in stage directions or personal directions.

CLOSE SHOT A camera cue. Includes the head and shoulders of a character.

CLOSEUP (C.U.) A camera cue. Closer than a close shot.

DISSOLVE A scene fades gradually, usually into the next scene.

DOLLY A camera cue. The camera moves where indicated in the stage directions.

EXT. Exterior (of a building, for example.) Used in scene headings.

EXTREME CLOSEUP A camera cue. Closer than a close shot or closeup.

FADE IN: Used at the beginning of a script or between scenes after a FADE OUT or FADE TO BLACK.

FADE OUT. Usually signals the end of a screenplay or the end of an act in a teleplay. Sometimes this will be used in the middle of a script; it might be written as FADE TO BLACK.

f.g. Foreground. Opposite of b.g.

FREEZE FRAME A camera cue. The moving picture becomes a still photograph.

INSERT This is used as a scene heading when the camera is to focus on a particular object. It is followed by the heading BACK TO SCENE or by a new scene heading.

INT. Interior (of a building, a room, etc.). Used in scene headings.

LONG SHOT A camera cue. From a distance.

MED. SHOT A camera cue. Usually shows the characters from the waist up.

MONTAGE A scene heading used to indicate the blending of two or more subjects at the same time, a kind of collage on film.

MOVING SHOT A camera cue. The camera moves along with the subject of the scene.

O.C. Off camera. This is usually used in television productions where three cameras are at work. Dialogue or sounds coming from outside the cameras' point of view are "o.c."

O.S.

Off screen or off stage. This is used in screenplays to indicate the same thing as O.C.: dialogue or sounds coming from outside the camera's point of view. The term is in CAPS (O.S.) beside a character cue, and lower case (o.s.) in stage directions.

PAN

A camera cue. The camera moves from right to left or left to right.

P.O.V.

"Point of view" of a character. The audience sees what the character is supposedly seeing.

SERIES OF SHOTS

A scene heading. This is followed by a list of stage directions indicating action shots.

SFX

Sound effects. In ALL CAPS in stage directions. Technical reproduction is usually necessary for these. The sound of BUBBLING would be a sound effect. A character sighing would not be a sound effect.

SPFX:

Special effects. Technical reproduction is usually necessary here. A BOMB EXPLODING would require special effects.

SPLIT SCREEN The screen is split to show different subjects or activities at the same time. An example would be splitting the screen to show two people talking on the phone to each other.

STOCK Archival film footage that can be used in a film without having to be reshot.

SUBJECTIVE CAMERA Similar to P.O.V. The camera behaves as the "eyes" of a character, showing what the character sees.

SUPER Superimpose. Something is "pasted" on top of the scene. Subtitles for foreign films are superimposed, for example.

VOICE OVER (V.O.) Not quite the same as off screen. In this case, an off screen character's voice is reproduced as if transmitted over a machine like a telephone. Voice overs are often used to relay a character's thoughts while other activity is shown on the screen.

ZOOM A camera cue. The camera rapidly moves toward or away from the subject of the scene.

PROOFREADER'S MARKS

ℓ	delete; take ~~it~~ out
◡	close up; print as o͡ne word
ℓ	delete and clo~~o~~se up
∧ or > or h	caret; insert here ⌒(something
#	insert a space
eq #	space evenly where indicated
stet	let marked ~~text~~ stand as set
tr	transpo~~es~~; change/order (the)
/	used to separate two or more marks and often as a concluding stroke at the end of an insertion
⌐	⌊set farther to the left
⌐ set⌋	farther to the right
⌒	set a͡e or f͡l as ligatures æ or fl
=	straighten align͞ment
‖ ‖	straighten or align

✕	imperfect or broken character
□	indent or insert em quad space
¶	begin a new paragraph
ⓢⓟ	spell out (set (5 lbs.) as five pounds)
cap	set in capitals (<u>CAPITALS</u>)
s.c. or *sm. cap.*	set in small capitals (<u>SMALL CAPITALS</u>)
lc	set in /lower case (lowercase)
ital	set in italic (*italic*)
rom	set in *roman* (roman)
bf	set in boldface (**boldface**)
= or -/or ⌃ or /H/	hyphen
⊢N or *en* or /N/	en dash (1965-72)
⊢M or *em* or /M/	em − or long − dash
∨	superscript or superior (²∨ as in r^2)
∧	subscript or inferior (∧ as in H_2O)
◇ or ∧	centered (◇ for a centered dot in p·q)
∧	comma
∨	apostrophe
⊙	period
; or ;/	semicolon
: or ⊙	colon
⟨⟨ ⟩⟩ or ∀∀	quotation marks
(/)	parentheses
[/]	brackets
ok/?	query to author: has this been set as intended?

INDEX

ABOUT THE AUTHOR

The bestselling author of *THE ROTATION DIET COOKBOOK* and *THE LOW FAT GOOD FOOD COOKBOOK* (both with Martin Katahn, Ph.D.), T. L. Katahn has written, co-written or been editorial consultant on a variety of books, video scripts and educational materials. Publications include short stories, poems, articles and, forthcoming in 1997, a novel under the name of "Reyna Thera Lorele."

T. L. Katahn worked as a professional story analyst in preparation for writing *READING FOR A LIVING*.

WRITE TO US!

We at Blue Arrow Books would like to know whether this book was helpful to you. Also, future editions will be updated, so any current information you can share will be a great service to us and our readers.

Our address is:

Blue Arrow Books
P. O. Box 1669-113
Pacific Palisades, CA 90272

NOTES

READING FOR A LIVING is:

" . . . a fabulous reference. . . . Since 'reading' is largely self-taught, it's nice to have one book that gives you everything you need to know."
— *Gibran Perrone*
Executive Assistant, Shinbone Productions

" . . . required reading for all my story analysts. . . . (This) wonderful book should be read not only by those who want to read for a living, but also by those who want an executive position in development and by screenwriters, producers, actors, etc."
— *Andrew Fumento*
Development Assistant/Story Editor, All Girl Productions

"A most informative book. Can be used as a work tool over and over again."
— *LeRoy Murphy*
Eddie Murphy Productions

"A complete and concise guide to gaining employment on the front lines of the film industry. . . . The chapter on evaluating the work should be read by everyone, from scriptwriters to development executives. A welcome addition to film literature."
— *Carl Kraines*
Producer

"I recommend (READING FOR A LIVING) to anyone who is interested in becoming a story analyst or trying to sell a script. . . . Not only did it help me get my first job reading for a producer, I use it almost daily as a checklist for making sure my comments are complete."
— *Cynthia Davis*
Story Analyst/Producer

"For a writer, it is important to know what the studio reader thinks about, and as a producer, it helps to know where the writer is coming from. An excellent in-depth look at both sides of the script! I recommend this book to writers and readers alike."
— *Chris Williams*
VP Development, Stargate Films

ORDER FORM

Mail to:
Blue Arrow Books
P.O. Box 1669-113
Pacific Palisades, CA 90272

Please send me ____ copy/copies of READING FOR A LIVING at $12.95 per copy. I enclose my check or money order made out to Blue Arrow Books. I understand that I may return the merchandise in good condition at any time for a full refund.

Sales Tax: California residents only, add 6.75% per copy.
Shipping: Add $2.00 for the first book, 75 cents for each additional book.

Subtotal for books:	$ _____
Plus tax if applicable:	_____
Plus shipping:	_____
Total enclosed:	$ _____

Name: Mr./Ms. _____

Company Name: _____

Address:_____

City:_____ State:_____ Zip:_____

Phone: H (___) _____ W (___)_____

We ship as quickly as possible, but please allow 4-6 weeks for delivery.
_____ Check here if you're in a hurry. We will ship your order air mail. Please enclose $3.00 shipping charge per book.